POCKET
IMPRESSIONISTS

TEXT BY STEVE DOBELL

PAVILION

This edition published in 1999 by
PAVILION BOOKS LIMITED
London House, Great Eastern Wharf,
Parkgate Road, London SW11 4NQ

Originally published in the Pocket Painters series
in 1995

Text by Steve Dobell
Designed by Andrew Barron & Collis Clements
Associates
Picture Research by Linda Marshall

A CIP catalogue record for this book is available
from the British Library

ISBN 1 86205 108 9

Printed in Hong Kong by Imago
Typeset in Galliard

9 8 7 6 5 4 3 2

This book may be ordered by post direct from the
publisher. Please contact the Marketing
Department. But try your bookshop first.

Contents

Introduction to Impressionism

The unrivalled popularity of the
Impressionists is a remarkable
phenomenon. Impressionism contains
such a diversity of styles and subjects
that any precise definition of it would
exclude much of the work of some of
the movement's leading figures – not
all of whom even claimed membership.

At the outset in the 1860s Monet and
his friends were indeed united, not
least by the spirit of rebellion. Inspired
by the bold example of the realists
Courbet and Manet, they rejected
traditional ideas out of hand. For a
few years around 1870 the group even
had some coherence at a technical
level. When Monet and Renoir were
painting together at Bougival on the
Seine, and Pissarro and Cézanne in
the Norman countryside around

Pontoise, they and others had a common goal. This was to respond directly and honestly to the sensations received by the eye while working in front of nature in the open air. That is to say, to paint not the form of what they knew to be there but what they actually saw – the *impression* received intuitively from nature. They were not composing but recording, and they did it by applying patches of colour in bold, spontaneous brush-strokes rather than through the careful mixing of colour in the classical manner.

Of the leading Impressionists it was Monet and Pissarro who adhered most consistently to this principle. For the others, Impressionism was a passing phase or a point of departure, while one or two never fully espoused it at all. Degas, for example, scorned *pleinairiste* painting and was more

interested in form and draughtsmanship than in colour. Although he exhibited regularly with the group, he never called himself an Impressionist. The main modern influences on this essentially classical painter were photography and Japanese art. Manet's radicalism and personality made him a rallying point for the young rebels, but he never exhibited with them. Another studio painter, he had a brief and colourful flirtation with Impressionism in 1874, then concentrated mainly on naturalistic depictions of his Parisian *milieu*.

Two painters who rejected Impressionism and reverted to classical influences were Renoir, who applied his mellow craftsmanship to warm, sensual depictions of human relations and the nude form, and Cézanne,

whose quest for solidity and structure in landscape brought him to the borders of abstraction. Van Gogh and Seurat learned from Impressionism and moved off in opposite directions, emotional and cerebral respectively. Rousseau, meanwhile, shared the same air but little else as he trod his uniquely independent path.

What all these painters had in common was the simple conviction that everyday life was a suitable subject for art. This modernity was as shocking to their contemporaries, and provoked as much hostility, as some of the works which win prizes in the 1990s. Today they all contribute in their different ways to a glowing composite portrait of *belle époque* France, while their very name, coined as a snort of critical derision, encapsulates a golden age of painting.

PISSARRO

1830 — 1903

Pissarro

Camille Pissarro (1830-1903) was born in the Virgin Islands, the son of a Creole mother and a French-Jewish father. By the age of 25, after two years of painting in Caracas, Venezuela, Pissarro was committed to an artistic career. He sailed to France in 1855 and settled at Passy, on the outskirts of Paris, where he had previously been at boarding school.

He attended various academic studios in Paris, and by the end of the decade

had also received advice on landscape painting from Corot, become friendly with Monet, and exhibited at the Salon. The 1860s saw him painting in the country and, after 1866, living there, first at Pontoise, then at Louveciennes. During the Franco-Prussian War he worked in England, and in 1872, now married, he settled in Pontoise. There he concentrated on his serene landscapes, until in about 1880 he turned his attention to his honest, matter-of-fact studies of peasants and their work.

In the Impressionist movement Pissarro was a constant source of strength and unity. He helped Monet to plan the first group exhibition, and would be the only artist to take part in all eight of them. He was a natural teacher, and always willing to share his discoveries with other artists,

such as Cézanne and Gaugin, who came to paint with him at Pontoise. Regarded by his young friends with great affection and admiration, he performed an almost pastoral role in the movement. No one did more to reconcile the quarrelsome elements or to promote the advancement of the group as a whole.

Far from being dogmatic about Impressionism, however, Pissarro was equally encouraging to those, like Seurat and van Gogh, whose development was clearly taking them in a different direction. Indeed, Pissarro himself became fascinated by Seurat's theories of divisionism, and after moving to Eragny in 1884, he experimented with the new system. In 1890, however, he pronounced himself to be dissatisfied: *'The manner of execution is not swift enough for me,*

and does not respond simultaneously with the feelings within me.' Undoubtedly it was the spontaneity of Impressionism that suited Pissarro best and he now reverted to a style more like that of the 1870s.

From 1888 until the end of his life Pissarro was dogged by eye trouble, which prevented him from painting outdoors. He converted a barn for use as a studio, and later took to staying in hotels in Paris and Rouen and painting a series of panoramic street and river scenes. He also painted latterly in Dieppe and Le Havre, but mainly divided his time between Eragny and Paris. It was in Paris that this benevolent artist – through whom the spirit of Impressionism had flowed perhaps the most constantly and purely – died of blood poisoning in 1903. ◢

The Entrance to the Village of Voisins

Oil on canvas
c.1872
46 × 55.5 cm

'You must go into the countryside,' Corot had said to the young Pissarro, *'the Muse is in the woods.'* The advice was good, for the gentle landscape of the Ile de France offered a range of subject-matter, such as this village scene near Louveciennes, which suited him admirably.

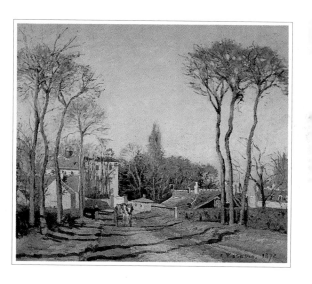

The Road to
Louveciennes

Oil on canvas
c.1872
60 × 73 cm

When Cézanne joined Pissarro at Pontoise in the early 1870s, it was Pissarro's turn to offer advice and support, as he did to many younger artists. _'The humble and great Pissarro,'_ wrote Cézanne later, _'was like a father to me. He was a man to turn to for anything, something like God.'_

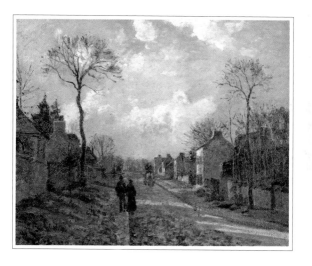

Landscape, Pontoise

Oil on canvas
c.1875
oo × oo cm

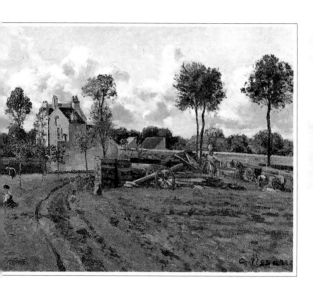

Previous page – Pissarro found his inspiration in almost every aspect of the countryside: village streets, animated market scenes, orchards and gardens, ancient tracks and clusters of farm buildings, often with peasants going about their everyday tasks. *'Everything is beautiful,'* he wrote to his son Georges, *'the important thing is to know how to interpret it.'*

The Little Bridge, Pontoise

Oil on canvas
c.1875
65.5 × 81.5 cm

That the châteaux around Pontoise never received Pissarro's attention in all his years there is perhaps not surprising in the light of his radical political beliefs. On this occasion he did at least enter the park at Marcouville, but, by careful framing of the bridge, contrived to disguise its surroundings.

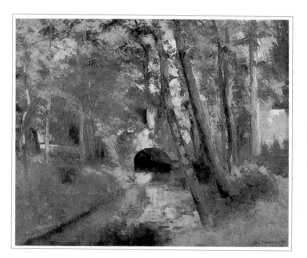

Harvesting at Montfoucault

Oil on canvas
c.1876
65 × 92 cm

Pissarro made several long visits to his painter friend Ludovic Piette at Montfoucault in Brittany, and some of his most memorable harvest scenes were painted there. This one dates from his last visit before Piette's early death in 1878, which left Pissarro badly shaken.

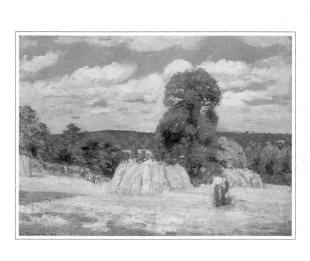

The Red Roofs,
Corner of a Village,
Winter

Oil on canvas
C.1877
54.5 × 65.5 cm

With its repeated shapes and its use of
the same colours – the red of the roofs,
the blue of the sky – in every part of
the canvas, this is one of Pissarro's
most instinctively controlled
compositions, showing a degree of
harmony and rhythmicality that is
reminiscent of the later Cézanne
landscapes.

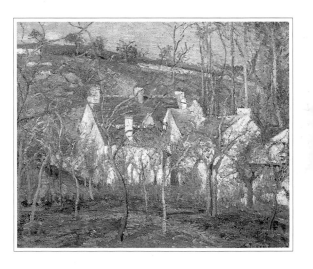

Orchard with Flowering Fruit Trees, Pontoise

Oil on canvas
C.1877
65.5 × 81 cm

Cézanne visited Pontoise in 1877 and also painted this very scene, from the back of Pissarro's house. But whereas Pissarro, using a multitude of tiny brush-strokes, succeeded in capturing the fleeting delicacy of the blossoms, Cézanne's painting, perhaps because he could not work with the necessary speed, was left unfinished.

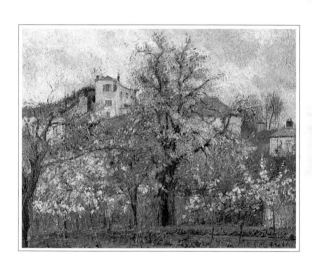

The Banks of the Oise, Cloudy Weather

Oil on canvas
c.1878
60 × 75 cm

Towards the end of his Pontoise period, Pissarro would often compose his paintings in such a way that the world of human activity is practically obscured by a natural barrier. Here, in a manner reminiscent of Corot, the factory building is seen through a complex screen of branches.

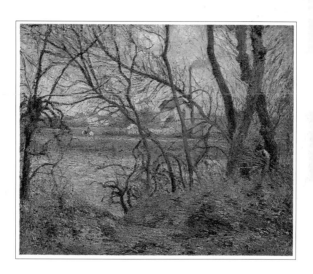

*Landscape at
Chaponval*

Oil on canvas
c.1880
54 × 65 cm

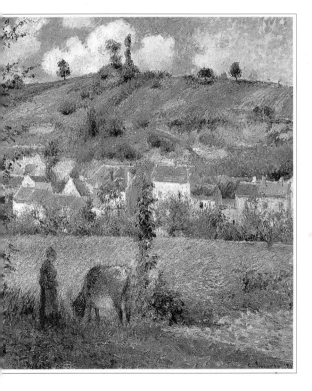

Previous page – While demonstrating Pissarro's tendency on some occasions to structure and simplify his landscapes, this charmingly tranquil scene conveys as clearly as ever the sense of an artist totally at ease with himself and his surroundings.

Girl with a Stick

Oil on canvas
c.1881
81 × 64 cm

This touching study of a peasant girl in thoughtful repose is remarkable both for being among the first of Pissarro's paintings, other than portraits of family and friends, to give such prominence to the human figure, and for its heightened emphasis by the use of an almost abstract background.

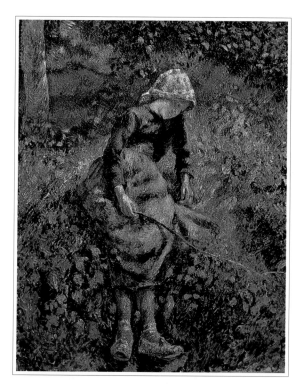

Young Woman Washing Dishes

Oil on canvas
c.1882
82 × 65 cm

As Pissarro increasingly brought figures into the foreground, he also began to show them engaged in specific activities. Domestic scenes such as this complement his depictions of men and women at the market or at work in the fields to provide a rounded portrait of the life of the French peasantry.

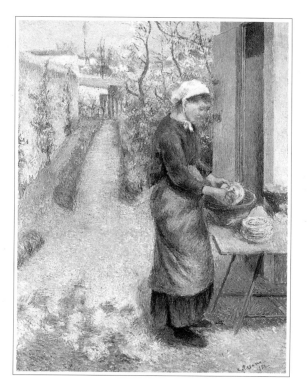

The Cabbage Slopes

Oil on canvas
c.1882
80 × 65 cm

Among the last paintings of Pissarro's Pontoise period, and one of his most structured and synthesized landscapes, *The Cabbage Slopes* also conveys his immersion in the rural life. As the critic Gustave Geffroy noted, *'He knew intimately the rhythms of flowerings and harvest, the passage of natural time'.*

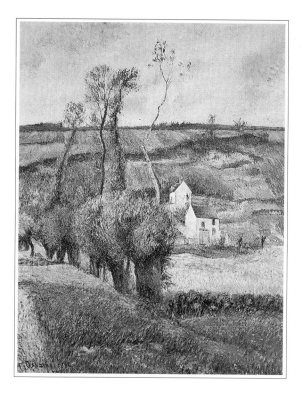

The Road Climbing to Osny

Oil on canvas
c.1883
55 × 65 cm

In 1882, after ten years at Pontoise, Pissarro and his family moved out to the village of Osny, just north-west of Pontoise on the River Viosne. In the summer of 1883 he was joined by Paul Gauguin, then on the brink of giving up stockbroking to paint full-time, for whom the visit proved both fruitful and decisive.

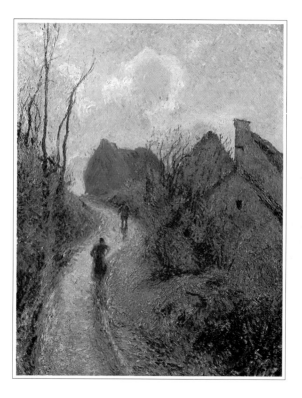

The Stream at Osny

Oil on canvas
c.1883
55 × 65 cm

Pissarro's move to Osny was never going to be more than temporary, for he felt he had exhausted the subjects available in the Pontoise area. He was now looking for a different kind of landscape, and after much exploration he chose the village of Eragny-sur-Epte, which offered a more traditional agricultural *milieu*.

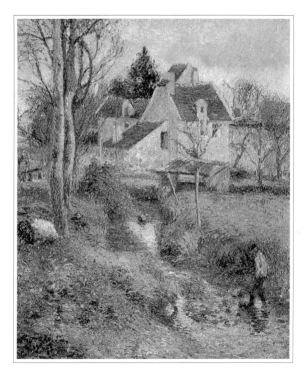

The Flood at Eragny

Oil on canvas
c.1893
65 × 54 cm

By the end of the 1880s, Pissarro's enthusiasm for the discoveries of Neo-Impressionism had waned, but instead of rejecting divisionism out of hand, he continued to draw on it from time to time. There are still traces of Seurat's influence to be found in some of his later landscapes at Eragny.

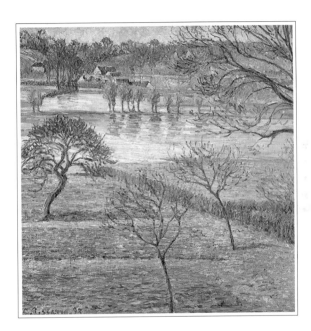

The Siesta,
Eragny-sur-Epte

Oil on canvas
c.1899
65 × 81 cm

Where Millet and van Gogh tended to
sermonize on the hardships of peasant
life, Pissarro painted it directly, in all
weathers, exactly as he saw it.
He saw no problem in showing
that even agricultural work had its
compensations – and that the toil
sometimes had to stop.

***Place du Théâtre
Français, Paris,
Spring***

Oil on canvas
c.1898
65.5 × 81.5 cm

In three months early in 1898 Pissarro
painted thirteen views from the Grand
Hôtel du Louvre. Unlike Monet's
interdependent series paintings, each
of Pissarro's stands on its own.
Moreover he constantly varied the
composition, sometimes including the
majestic sweep of the Avenue de
l'Opéra, sometimes just a slice of the
capital's bustling street life below his
window.

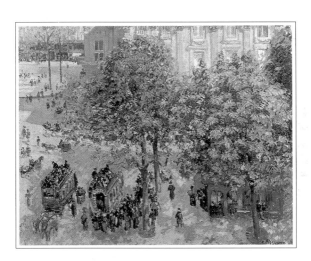

Sunrise, Rouen

Oil on canvas
c.1898
65 × 81 cm

If Pissarro felt constricted by no longer being able to work in the open air, his choice of painting from high vantage-points in hotel rooms often had the effect, in his late urban canvases, of vastly broadening his horizons. Here, in the pure light of early morning, one has the sense of an entire city coming to life.

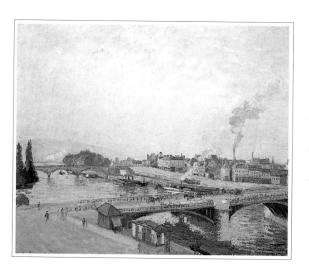

M A N E T

1 8 3 2 — 1 8 8 3

Manet

Edouard Manet (1832-1883) had
a strangely contradictory career,
not least in his relationship to
Impressionism. Commonly regarded
in his day as the leader of the
movement – and no one had greater
influence on its incubation – he
scarcely even joined it. Although
ideas were fruitfully exchanged
between him and the Impressionists,
he never exhibited with them. His
sights were firmly set on recognition
by the Academy and success at the

Salon. Yet he was temperamentally too rebellious to give them what they wanted, persisting instead in submitting work so uncompromisingly modern that most of it was savagely attacked. The rejection, in effect, was mutual.

Manet's affluent family had wanted him to be a lawyer, but in 1850 he was finally allowed to enter the studio of Thomas Couture. He also studied at the Académie Suisse and painted at Fontainebleau with the Barbizon artists. In 1856 he returned from a Grand Tour of European galleries greatly impressed by the Dutch painter Franz Hals. Apart from the revolutionary realism of Gustave Courbet, which helped set him at loggerheads with the art establishment, his other main influences were Velasquez and Goya, and he never

lost his love of strong but subtle contrasts of dark and light.

Fortunate enough to be able to rent his own studio, in 1859 Manet began his campaign for admittance to the Salon. Early successes were overshadowed, however, by the rejections which perversely made his name, notably the public outrage over *Le Déjeuner sur l'Herbe* and *Olympia*, with their perceived disrespect for the Renaissance masters he seemed so casually to plagiarize. Manet's radical style of painting and dangerous image made him a hero to younger artists, who flocked to the Café Guerbois, where the sharp-tongued, elegant rebel held court. *'One emerged,'* wrote Claude Monet, *'with a stronger will and thoughts sharpened and clear.'* Later their roles were briefly reversed when Manet became a *pleinairiste* disciple

of the younger man and, in 1874 at Argenteuil, produced a dazzling series of Impressionist paintings. He brought the same fresh palette and free handling to his work in Venice in 1875, and, partly owing to his habit of priming his canvases with white, his indoor café scenes of the late 1870s, like his vibrant garden scenes of 1880, have a luminosity and richness of colour.

By this time Manet was suffering from a disease affecting his muscles, which grew steadily and painfully worse. In 1881 he was belatedly awarded the Légion d'Honneur but the greater prize, full recognition of the true value of his work, came too late for Manet altogether. On 20 April, 1883, ten days after the amputation of his gangrenous left leg, the charismatic *flâneur* died in Paris at the age of 51. ◼

Lola de Valence

Oil on canvas
1862
123 × 92 cm

Spanish subjects were all the rage in
mid-nineteenth-century Paris, and
Manet hoped for Salon success with
his Goyaesque portrait of Lola Melea,
the star of a popular Spanish dance
company. In that he was disappointed,
but the Spanish influence soon became
a profound one when he visited Spain
in 1865 and discovered Velasquez.

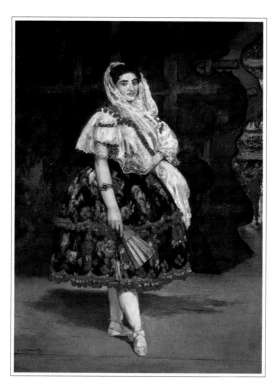

Le Déjeuner sur l'Herbe

Oil on canvas
1863
208 × 264 cm

The *succès de scandale* of the 1863 Salon des Refusés was pilloried primarily for its subject-matter: '*A commonplace woman of the* demi-monde, *as naked as can be, shamelessly lolls between two dandies dressed to the teeth,*' hissed one critic. Equally shocking were Manet's 'updating' of a Renaissance engraving – and the model Victorine Meurent's nonchalant gaze.

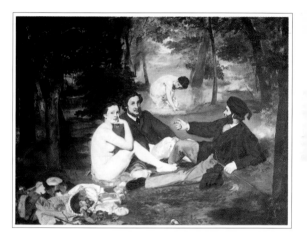

The Fifer

Oil on canvas
1866
160 × 98 cm

With both Japanese and Spanish
influences discernible in its flat areas of
colour and the sharp definition of the
figure against the grey background,
The Fifer was well ahead of its time.
After Manet's death its power and
immediacy were recognized, but the
critics of 1866, like the Salon, saw only
the flatness.

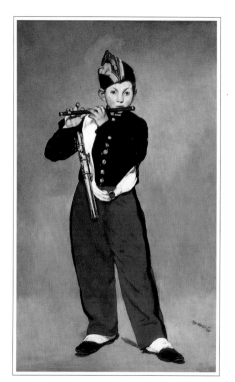

Portrait of Emile Zola

Oil on canvas
1868
146 × 114 cm

The novelist Emile Zola was an early and constant supporter of Manet. In 1866 he had written a staunch defence of *The Fifer* in *L'Evènement*, for which he was dismissed. Manet responded by painting Zola's portrait which, by including a Japanese print, an engraving of a Velasquez and Manet's own *Olympia*, represents a statement of their shared tastes.

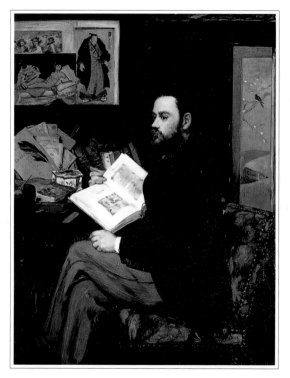

*Boulogne Harbour
by Moonlight*

Oil on canvas
1869
82 × 101 cm

In the late 1860s, on doctor's orders,
Manet made several visits to Boulogne.
In the summer of 1869, while Monet
and Renoir were at Bougival develop-
ing their Impressionist technique,
he too began to paint outdoors.
This moonlit scene was among the
first of his paintings to be bought by
the dealer Paul Durand-Ruel.

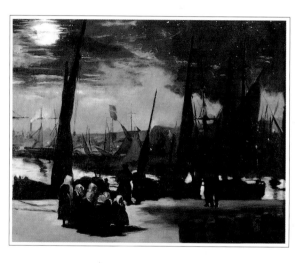

The Reading

Oil on canvas
1869 – 73
61 × 74 cm

Manet began this charming portrait of
his wife Suzanne in 1865, and years later
added the figure of his stepson (and
possibly half-brother) Léon – by now
a young man. The use of whites and
greys suggests the influence of Berthe
Morisot as well as Whistler's *The White
Girl*, another controversial exhibit at
the 1863 Salon des Refusés.

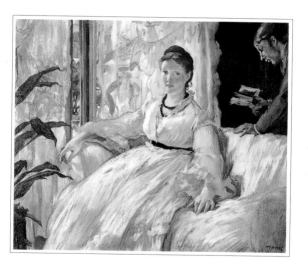

Portrait of
Berthe Morisot

Oil on canvas
1872
55 × 38 cm

Berthe Morisot and Manet met at the Louvre in the late 1860s and became great friends. This close-up portrait – a rare thing for Manet – testifies to their mutual respect. A remarkable painter herself, who embraced Impressionism whole-heartedly, Morisot sat for Manet several times, and married Eugène Manet, his younger brother, in 1874.

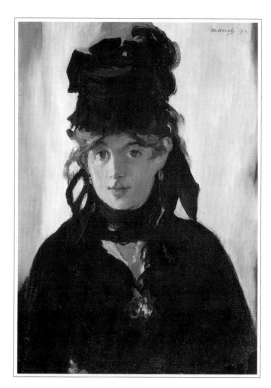

The Railway

Oil on canvas
1873
93 × 114 cm

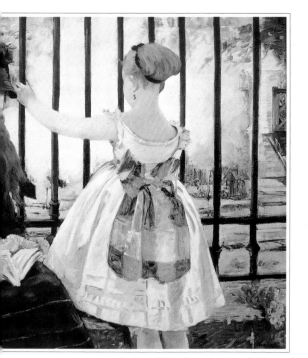

Previous page – Railways fascinated Manet, which was just as well, as his studio shuddered every time a train crossed the Pont de l'Europe, just visible on the right of the picture. Manet used the garden of his neighbour, the artist Alphonse Hirsch, in which to paint the figures, for which Victorine Meurent and Hirsch's daughter posed.

On the Beach

Oil on canvas
1873
59.5 × 73.2 cm

In July 1873 Manet returned to the Boulogne area to soothe his nerves at Berck-sur-Mer. There he painted several seascapes, including this brightly lit, wonderfully atmospheric study of his wife Suzanne and brother Eugène, who loom so large and look so ensconced that they appear to be an organic part of the scene.

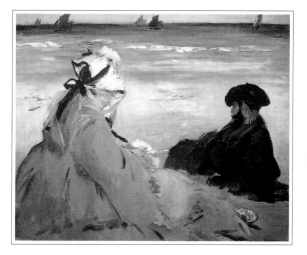

*The Monet Family
in the Garden*

Oil on canvas
1874
61 × 100 cm.

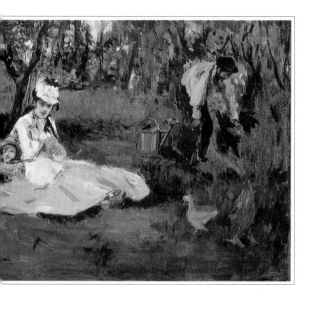

Previous page – *'Who is this Monet, whose name sounds like mine and who is cashing in on my notoriety?'* Manet is said to have exclaimed irritably in 1865. Within a decade the two were happily painting together at Argenteuil. On this occasion, Manet and Renoir painted side by side, while Monet attended to his border.

Argenteuil

Oil on canvas
1874
149 × 115 cm

In the summer of 1874, following the Impressionists' first group exhibition, Argenteuil was the epicentre of the movement. Even Manet, staying at Gennevilliers on the opposite bank, briefly became a mainstream Impressionist. This vibrant sunlit canvas, with the familiar Argenteuil skyline visible behind the characteristically dominant figures, was accepted – and reviled – at the Salon.

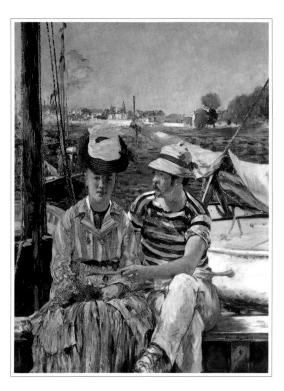

The Grand Canal, Venice

Oil on canvas
1875
57 × 48 cm

In 1875 Manet visited Venice with James Tissot, and the two works which survive appear to have been painted from the Palazzo Barbaro, where they were guests of a rich American. In this boldly Impressionist painting of the Grand Canal, also known as *Blue Venice*, the dome of the Salute can be seen behind the striped *palli*.

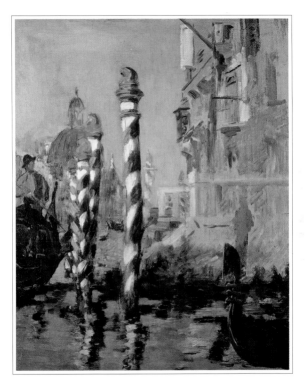

Nana

Oil on canvas
1877
150 × 116 cm

The first of Manet's naturalistic
Parisian scenes, the 'immoral' *Nana*
was predictably rejected by the Salon.
Displayed in a shop window, it
attracted such huge crowds that the
police had to be called. Although the
novel *Nana* was published later, the
figure is indeed based on Zola's
courtesan, who also appeared in
L'Assommoir, serialized in 1876.

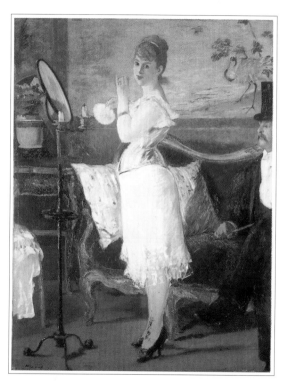

At the Café

Oil on canvas
1878
77 × 83 cm

Ever the Parisian *flâneur*, Manet
revelled in the atmosphere of cafés
and cabarets, where people of all
types rubbed shoulders in relaxed,
often seedy surroundings. This is
part of what was originally a much
larger canvas. The result failed
to satisfy Manet, who, not for the
first time, simply cropped it.

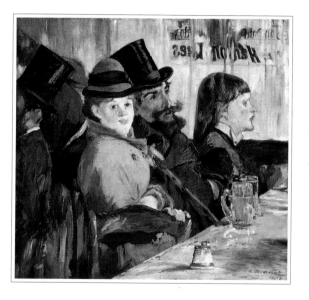

The Waitress

Oil on canvas
1879
93 × 70 cm

Waitresses were a new phenomenon, and Manet admired the way they handled the heavy beer glasses. This is a re-working of what began as the right-hand portion of *At the Café*. The back of the drinker in the foreground shows where Manet added a strip of canvas on the right.

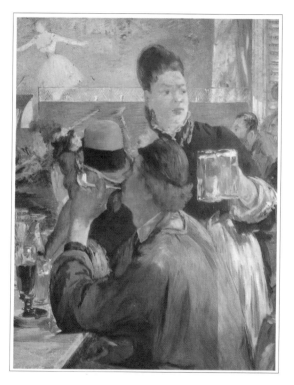

Brioche with Cat and Pears

Oil on canvas
c. 1880
55.4 × 35 cm

From the mid-1860s, and especially later, when his health kept him indoors. Manet frequently painted still-lifes. Many were small compositions, consisting of a single subject: a lemon, a joint of ham – once even a single asparagus. This unusual study of brioche, rose, cat and pears shows his continuing love of strong contrasts.

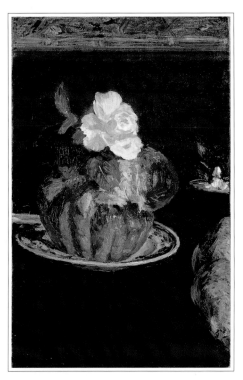

Un Bar aux
Folies-Bergère

Oil on canvas
1881 – 2
96 × 130 cm

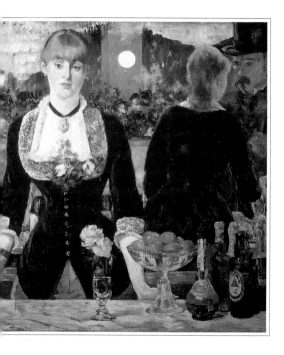

Previous page – Manet's last major work is a *tour de force*: combining its subtle figure study and its masterly still-life elements with the conviviality of the atmospheric scene reflected in the mirror. Although Manet was never more than a provisional Impressionist, this is one of the undisputed masterpieces of Impressionism.

The House at Rueil

Oil on canvas
1882
92 × 73 cm

In 1882, his illness worsening, Manet reluctantly left Paris, renting a house at Rueil-Malmaison. Eight years after his Impressionist interlude with Monet, he was back in Impressionist country – but this time feeling like an exile. In this otherwise spontaneous view of the house the composition is characteristically structured; the absence of figures, for Manet, unusual.

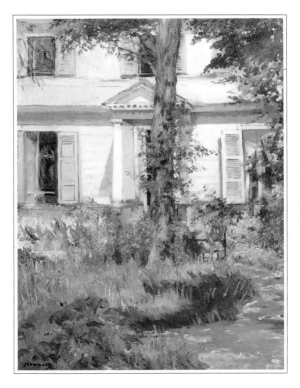

***Roses and Tulips
in a Vase***

Oil on canvas
1882 – 3
54 × 33 cm

Manet's last paintings were a series of
exquisite studies of flowers, none more
vibrant with life and sparkle than this
natural arrangement in a Japanese
crystal vase decorated with a dragon.
His final work shows no hint of the
pain and frustration we know he felt,
as he uses the only subject-matter left
to him to sign off, as it were, with his
customary panache.

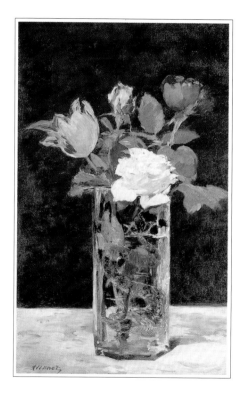

DEGAS

1 8 3 4 − 1 9 1 7

Degas

Edgar Degas (1834-1917), born in Paris into a prosperous banking family, was a powerful force in the Impressionist movement and yet its most independent member. His studies at the Ecole des Beaux-Arts, the influence of Ingres and the Renaissance artists whose work he copied during formative periods spent in Italy, gave him mastery of draughtsmanship and traditional techniques of oil painting. From 1865 he was exhibiting regularly at the

Salon, at first mostly portraits and historical scenes. Soon, however, he dismayed the art establishment by switching to contemporary subjects and, influenced by Manet and his circle, a freer compositional style.

Degas took part in the first Impressionist exhibition of 1874 and all but one thereafter, and was responsible for bringing Mary Cassatt, among others, into the movement. Thanks to his inherited wealth he was not obliged to make compromises in order to sell paintings for his living, and through-out the rest of his life, during which he remained a somewhat reclusive bachelor and seldom left Paris, he dedicated himself to his art with complete single-mindedness.
He found his subjects in the daily life of the capital: at the racetrack and

the ballet, and particularly in the movements and attitudes of people caught at their least self-conscious, absorbed in mundane activities.

It is not only in his choice of subjects that Degas stands apart from the other Impressionists, who were mostly concerned with the effects of light on water and landscape. He did not share their enthusiasm for painting in the open air, and preferred to be in his studio, using models or working from sketches. Arguably the greatest innovator of the movement, Degas was constantly trying out new materials and techniques. His use of flat areas of colour shows the influence of Japanese art, while the advent of photography led him to experiment with unusual perspectives and the cropping of limbs or even whole figures in order to achieve a

greater sense of immediacy and movement. When, toward the end of his increasingly isolated and unhappy life, his eyesight deteriorated, he took to working in pastels and eventually to sculpture.

Degas himself said that there was nothing spontaneous about his art, and of his methods this is true. Such was the technical virtuosity of this most cerebral of all the Impressionists, however, that his studies of women at their work or their toilette, and dancers in rehearsal or waiting to perform, have a naturalness, grace and vitality worthy of the Renaissance masters whom he so revered. ◪

The Bellelli Family

Oil on canvas
c.1858 – 62
200 × 253 cm

Degas began work on this thoughtful portrait of his aunt's family with a series of sketches made during his visit to Florence in 1858–9, which were worked up later in Paris. The combination of classical design and the sitters' highly natural attitudes is characteristic of his early portraits.

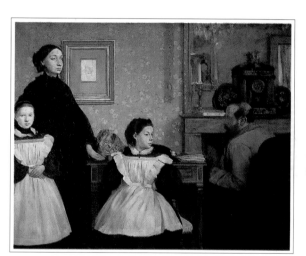

The Orchestra of the Opéra

Oil on canvas
c.1868 – 9
53 × 45 cm

Degas was so given, apparently, to re-touching paintings that his family were delighted when he gave this one to Désiré Dihau, the bassoonist, as it meant that one painting at least could be regarded as finished. Both the subject and the unusual perspective were to become Degas trademarks.

Overleaf – In this early treatment of his most famous subject, Degas shows the ballet-master Moraine teaching at the old opera house in the Rue Le Peletier. A year later the building was destroyed by fire, and Garnier's new Opéra replaced it in 1875.

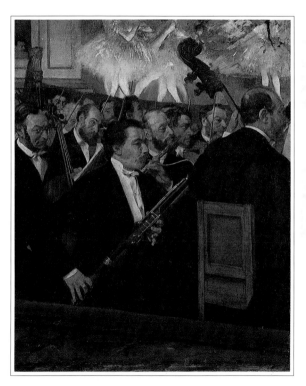

*The Dance Foyer
at the Opéra*

Oil on canvas
c.1872
32 × 46 cm

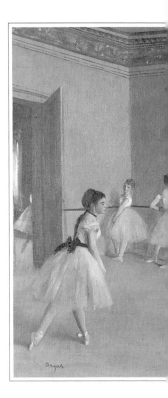

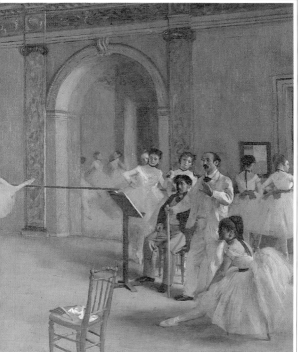

Dancers on the Stage

Oil on canvas

c.1873 – 4

61.5 × 46.5 cm

Degas was fascinated by the movements and attitudes of dancers who provided an inexhaustible source of material, both in graceful performance or rehearsal and in off-guard moments while resting or waiting to perform.

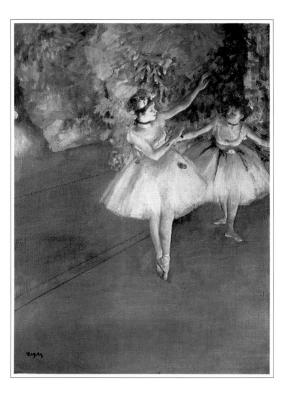

Dancers Resting

Pastel
c.1874
44 × 30.2 cm

Sore feet and tired backs would produce the strikingly natural attitudes which most appealed to the artist's eye. The coloured sashes were in fact seldom worn, but, as Degas remarked, *'Even in front of nature one must compose.'*

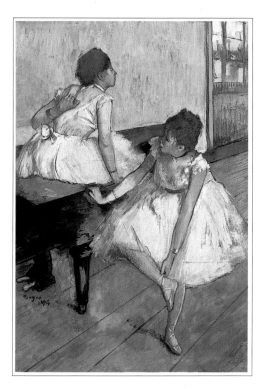

The Dancing Class

Oil on canvas
c.1874 – 5
85 × 75 cm

While one girl is coached, the others provide a gallery of unselfconscious poses. Years later Degas would write: *'Except for the heart, everything in me is ageing proportionally. And even the heart has something artificial about it. The dancers have sewn my heart into a bag of pink satin, slightly faded pink satin, like their dancing shoes.'*

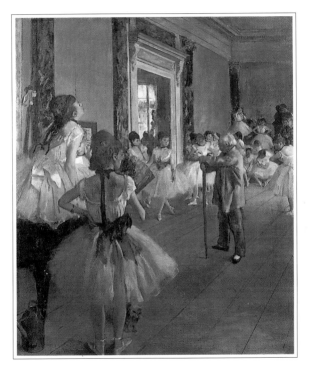

***Café-Concert at
Les Ambassadeurs***

Pastel over
monotype
c.1875 – 7
37 × 27 cm

In this atmospheric and carefully
composed cabaret scene, the eye is
continually led back to the singer.
The motif of hats and double bass
protruding above the line of the stage
would later be adopted by Toulouse-
Lautrec.

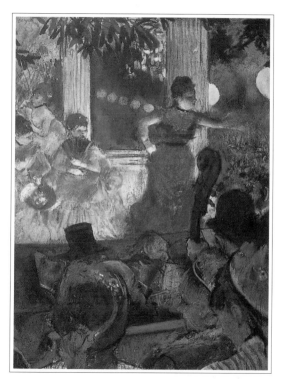

***Dancer on Stage
'L'Etoile'***

Pastel

c.1876

58.5 × 43.2 cm

One of Degas' earliest depictions of a
pas sauté, this pastel is pure movement.
Degas would later work increasingly
with pastels as his eyesight failed.

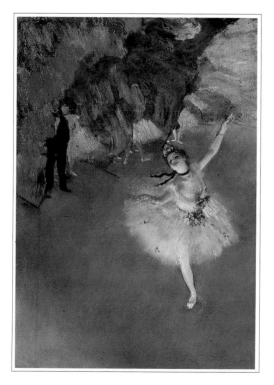

L'Absinthe

Oil on canvas
c.1876
92 × 68 cm

For this skilfully composed study in weariness, in which the eye is manipulated by the flat surfaces of the tables, two friends of Degas, Ellen Andreé the actress and Marcelin Desboutin the painter, posed at the Café Nouvelle-Athènes on Place Pigalle, then a favourite haunt of the Impressionists.

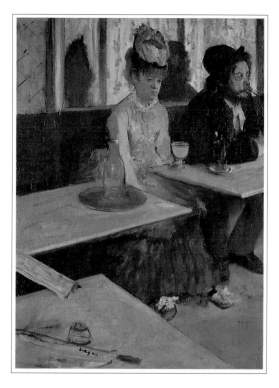

***Miss La La at the
Cirque Fernando***

Oil on canvas
c.1879
117 × 77.5 cm

The colour and movement of circuses
appealed greatly to Degas. Here the
viewer's eye is drawn irresistibly
upwards by the composition, as the
acrobat is by her teeth.

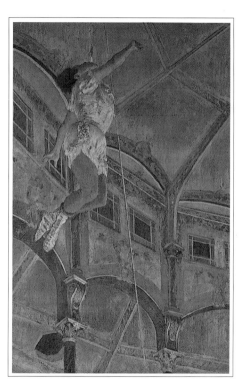

At the Bourse

Oil on canvas
c.1879
100 × 82 cm

The monochromatic treatment and strong rectangular shapes of the masonry give this scene at the Paris Stock Exchange an almost classical quality, whereas the preoccupied informality of the attitudes suggests a moment frozen by a snapshot, and the truncating of figures by the frame is wholly modern.

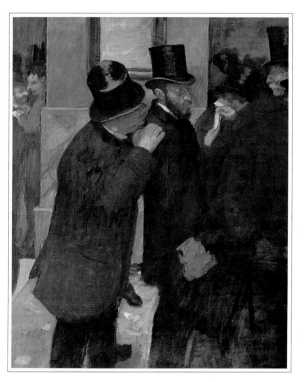

***At the Races, in
Front of the
Grandstand***

Oil on canvas
1866 – 8
46 × 61 cm

Alone among the Impressionists,
Degas found much to interest him at
the racecourse. Here he conveys the
sense of anticipation before the start
and the quality of late afternoon light,
his use of thinned paint creating an
effect not unlike that of pastels.

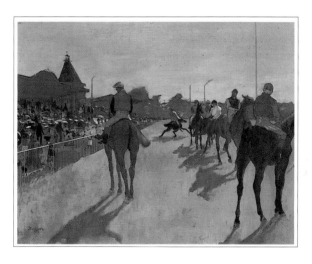

Breakfast
after a Bath

Pastel on paper
1883
120 × 92 cm

Women apparently caught off-guard in their daily routine of bathing, drying themselves or combing their hair provided Degas with ideal subject-matter. Here the vigorous movement of the woman drying her hair is contrasted with the steady control required to balance the cup and saucer.

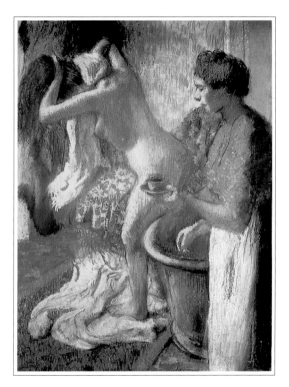

***Woman Combing
Her Hair***

Pastel
c.1887 – 90
80 × 57 cm

His preoccupation with women at
their toilette would seem intrusive, if
not obsessive, were it not for the cool
detachment of his observation. Far
from seeming either patronizing or
voyeuristic, these intimate scenes have
an almost hieratic quality.

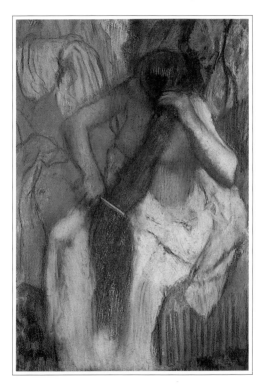

**Woman Drying
Herself**

Pastel
c.1889 – 91
104 × 98.5 cm

Degas was in no doubt about how
women in general felt about these
paintings. *'They hate me',* he said to
Georges Jeanniot, *'they feel that I am
disarming them. I show them without their
coquetry, in the state of animals cleaning
themselves!'*

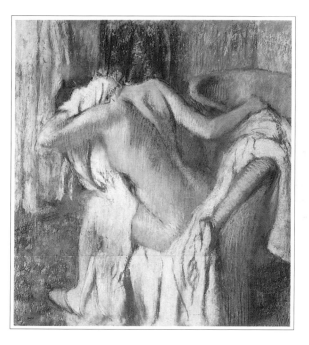

***Dancer in her
Dressing Room***

Pastel
1880
68 × 105 cm

An aficionado visits one of the
performers, perhaps a protégée, in the
intimacy of her dressing room. The
private nature of the interview is
emphasized by the barrier of the chair
in the foreground.

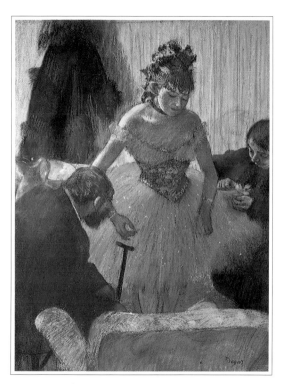

Woman Ironing

Oil on canvas
c.1880
80 × 63.5 cm

On solitary walks through the streets of Paris, Degas used to peer in through the windows of laundries to observe the women absorbed in their work. He would then return to his studio and, working from memory, recreate their weary postures and rhythmic movements.

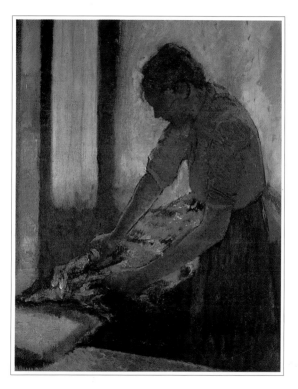

Before the Races

Oil on canvas
1868 – 70
46.5 × 37 cm

For his racecourse paintings Degas tended to choose moments either before or after races, concentrating on the attitudes of horses and jockeys as they waited or jostled, and on the colour and movement of the general scene. Although for the sake of accuracy he studied sequences of photographs of horses in motion, he seldom painted an actual race.

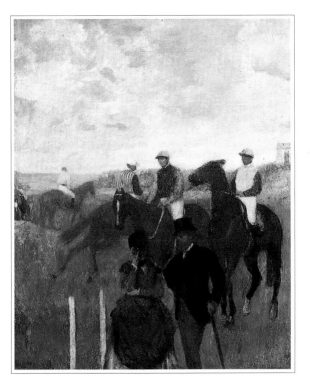

Two Women Leaning For Degas the studio was the only
on a Gate place to paint, and he never did more
than make preparatory sketches on the
Pastel spot. On hearing someone refer to the
1882 – 5 Impressionists' passion for painting
52 × 66.5 cm outdoors, he once exclaimed: *'Don't
speak to me of those old fellows who clutter
the fields with their easels!'*

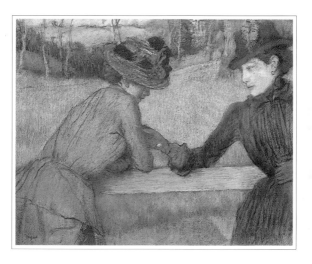

CEZANNE

1 8 3 9 — 1 9 0 6

Cézanne

The artistic development of Paul Cézanne (1839-1906) embraces elements of romanticism, Impressionism, classicism and abstraction, and is all the more remarkable for the fact that he was a countryman who spent most of his life in his native region and remained unashamedly provincial.

Cézanne was born and educated in Aix en Provence, and although artistic friendships and ambitions took him

north at various periods of his life, the area around Aix continued to be his spiritual home and the single most important influence on his art. Like Degas, he was the son of a banker and destined for the law, but in 1861 he gave up his legal training to follow his childhood friend Emile Zola to Paris. Here he met Camille Pissarro, who became a lifelong friend, and studied briefly at the Académie Suisse. The die was cast, and the following year saw him back in Paris, to seriously persue an artistic career.

When his early submissions to the Salon were rejected, the angry Cézanne perversely continued to submit paintings which stood little chance of success - oppressively dark and melodramatic compositions, the paint applied heavily with palette knife and brush. In the mid 1860s

Cézanne took to painting outdoors, and in 1872 he and Hortense Figuet (later his wife) joined Pissarro at Pontoise for two years, during which they often painted side by side and he came closest to mainstream Impressionism. Although on moving from Pontoise to nearby Auvers he gained a patron in Victor Chocquet, he was now more embittered than ever by the lack of public recognition. Even at the 1874 and 1877 Impressionist exhibitions his contributions had been singled out for derision. In 1878, with Hortense and their young son, he withdrew to Provence, where the most important phase of his career began.

No longer content like the Impressionists to capture fleeting effects of light on objects, he now aimed to express instead, through

painstaking analysis and the use of intense colour, their solidity and permanence. The chromatic art of his final years, notably his rhythmical, harmonious landscapes, can be seen both as a return to classicism ('Poussin again in contact with Nature') and a giant step on the road to abstraction.

Success came late in Cézanne's life, with a one-man show in Paris in 1895, but finally recognition had been achieved, and it may be that when he wrote in 1903, *I am working obstinately. I am beginning to see the promised land*, he may even have had an inkling of the historical significance of his lonely journey. ◼

The Orgy

Oil on canvas
1864 – 8
130 × 81 cm

Much of Cézanne's early work in Paris was influenced by Delacroix, and extravagantly romantic. He also had profound admiration for Poussin and used to copy his work at the Louvre.

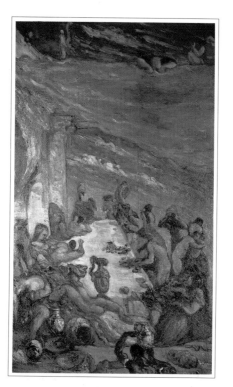

The Black Clock

Oil on canvas
1869 – 70
54 × 73 cm

Cézanne's still-lifes had drawn favourable comment from Manet as early as 1866. Throughout his career he was to bring the same dedication and detailed analysis to the still-life as he did to the landscape.

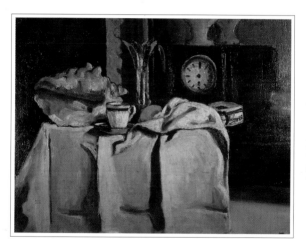

Bathers, Male and Female

Oil on canvas
c.1870
20 × 40 cm

During the Franco-Prussian War, Cézanne spent his time at Aix and L'Estaque, having avoided the draft. There he produced this early, small-scale treatment of a subject which would still be engrossing him at the turn of the century.

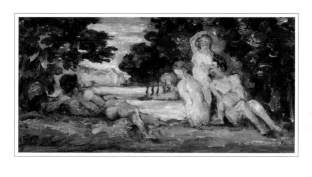

**Dr Gachet's House
at Auvers**

Oil on canvas
1873
46 × 37.5 cm

After working with Pissarro at
Pontoise, where he developed his
Impressionist style, in 1873 Cézanne
went to stay with Dr Gachet at nearby
Auvers-sur-Oise, where Vincent van
Gogh's sad journey was to end
eighteen years later. There Cézanne
met Victor Chocquet, who became his
first patron.

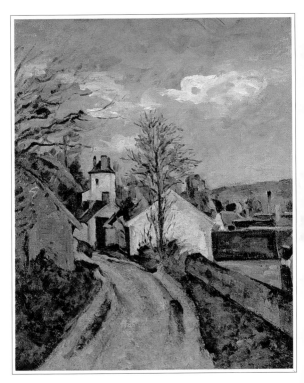

The Château de
Médan
(Zola's House)

Oil on canvas
1879 – 81
59 × 72 cm

Médan, near Paris, belonged to
Cézanne's old friend, the novelist
Emile Zola, whom he visited there
regularly between 1879 and 1885. Then,
incensed by Zola's unflattering
portrayal of him as the painter hero of
his novel, *L'Oeuvre*, Cézanne abruptly
broke off the friendship.

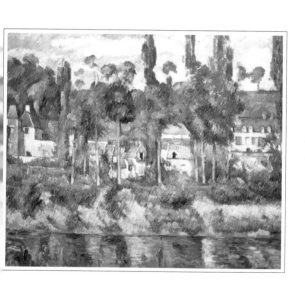

The Bridge at Maincy

Oil on canvas
1882 – 5
59 × 72 cm

Having shaken off the influence of Pissarro, and not having exhibited with the Impressionists since the third group show of 1877, Cézanne now spent most of his time in Provence, pursuing his investigations into the structure of landscape. Here the bridge provides strong horizontals to contrast with the vertical trees.

Overleaf – *'There are many views here, but none of them makes a proper motif. Even so, if one goes up into the hills at sunset, there is a fine panoramic view of Marseilles and the islands, which in the evening are shrouded in some very decorative light effects.'*
Paul Cézanne, 1882.

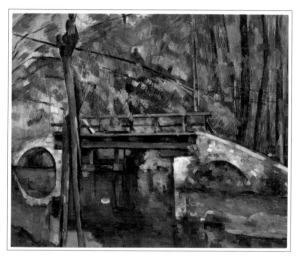

*L'Estaque, View of
the Bay of Marseilles*

Oil on canvas
1882 – 5
58 × 72 cm

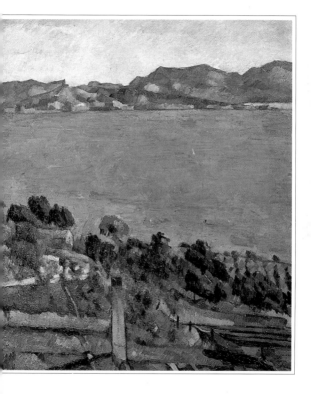

The Blue Vase

Oil on canvas
1883 – 7
61 × 50 cm

Incorporating a vase of flowers, which
would normally be painted on its own,
this still-life is also original in its use
of thin paint, rough blue outlines, and
subtle, harmonious gradations of colour,
producing the effect of simplicity
and grandeur.

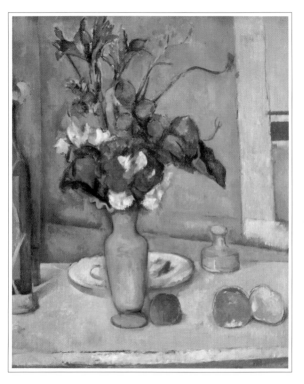

View of Gardanne

Oil on canvas
1885 – 6
92 × 73 cm

In this study of the village near Aix
where he rented a house, Cézanne is
already simplifying what he sees,
breaking things down into their
essential shapes. Colours and shapes
together have an almost abstract effect,
creating the impression that this is the
pure, archetypal Provençal village.

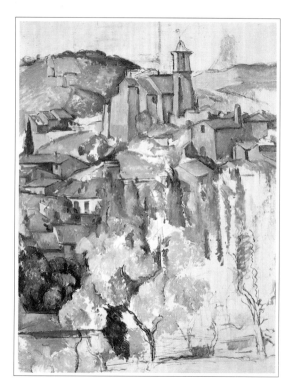

Still-Life with Basket

Oil on canvas
1888 – 9
65 × 80 cm

In this complex arrangement Cézanne is tinkering with axes and perspective to produce the kind of dislocation later developed by the Cubists. The ginger pot is tilted towards the viewer, and the jug and jar to one side, while the two ends of the table are completely out of alignment.

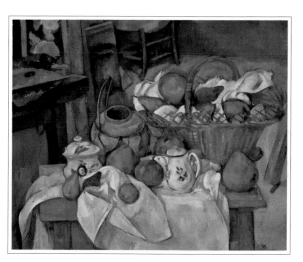

Boy in a Red Waistcoat

Oil on canvas
1890 – 5
92 × 73 cm

Rough in its texture, spontaneous in its brush-work, this study of a thoughtful boy, elegantly dressed in Italian peasant costume, is one of Cézanne's most sensitive and successful portraits. He painted it in Paris, where he still worked periodically, using a professional model named Michelangelo di Rosa.

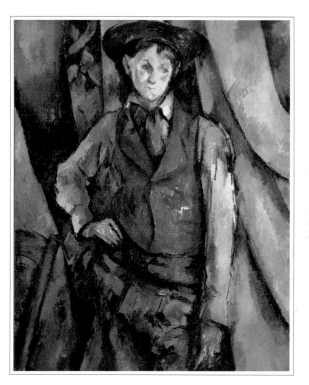

Still-life with Apples and a Jug

Oil on canvas
1895
54 × 73 cm

Louis Le Bail recalled Cézanne's preparations for one of these compositions: *'The cloth was draped a little over the table with instinctive taste; then he arranged the fruit, contrasting the tones one against another, making the complementaries vibrate, the greens against the reds, the yellows against the blues, tilting, turning, balancing the fruit as he wanted it to be, using coins of one or two sous for the purpose. He took the greatest care over the task and many precautions; one guessed that it was a feast for the eye to him.'*

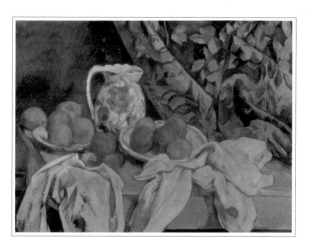

Château-Noir

Oil on canvas
1894 – 6
73 × 92 cm

'Painting,' wrote Cézanne, *'does not mean making a slavish copy of the object in view; it is capturing the harmony between variously related things.'* In his painting of a dramatic house between Le Tholonet and Aix, warring shapes are harmonized by the luminous colours of masonry and foliage.

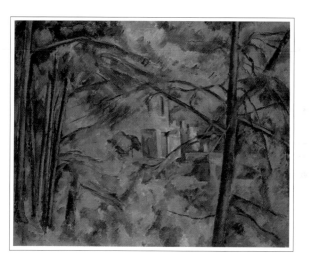

The Smoke

Oil on canvas
1895 – 6
92 × 73 cm

There is no pathos in Cézanne's work.
Once he had outgrown the Romantic
melancholy from which sprang his
morbid early compositions, there was
scarcely a reference to the emotional
side of life. Even his portraits tend to
be of people who, like this country-
man, look confident, balanced, stolid.

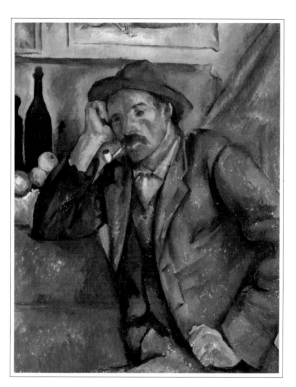

Vase of Flowers

Oil on canvas
c.1900
77 × 64 cm

Although conscious that he was a
pioneer and a revolutionary, Cézanne
nevertheless remained at heart a
student of painting, and was not too
proud, even near the end of his life, to
learn from the masters. This painting of
flowers and greenery is copied from a
watercolour by Delacroix.

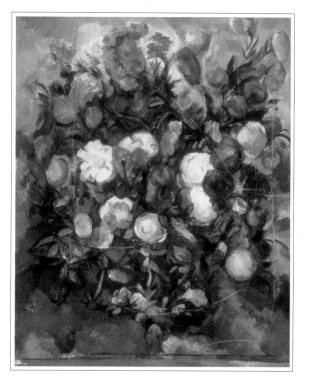

Still-life with Teapot

Oil on canvas
1900 – 5
58 × 70 cm

This late still-life is no less satisfying for being one of the least complex. The almost tangible fruit, its colour harmonized with the rich cloth, its roundness echoed by the teapot and jar, has something of the solidity and sensuality of a Renoir nude.

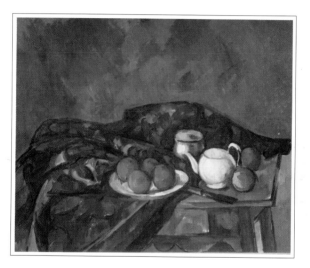

The Gardener

Oil on canvas
1900 – 6
63 × 52 cm

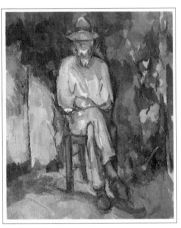

Left – In this study of his gardener Vallier, who was often pressed into service as a model, Cézanne uses very thin paint and the fluid brush-strokes normally associated with watercolours to produce a portrait of remarkable solidity and depth. This may be the painting on which he was working when he died.

Overleaf – *'What he most closely resembles is a Greek of the golden age. That imperturbable calm, in all of his canvases, is also found alike in ancient Greek painting or vases. Those who ridicule his* Bathers, *for example, are just like the Barbarians who find fault with the Parthenon.'* – Georges Rivière.

Les Grandes Baigneuses

Oil on canvas
1900 – 5
130 × 195 cm

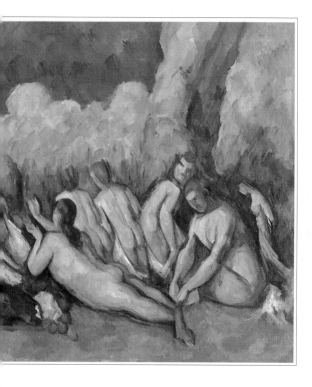

Mont Sainte-Victoire

Oil on canvas
1904 – 6
65 × 81 cm

The Mont Sainte-Victoire, which looms over the landscape to the east of Aix, also dominates the output of Cézanne's final years. He painted it repeatedly, in both oils and watercolours, and the later, almost abstract treatments of this favourite motif have come to symbolize both his achievement and his legacy.

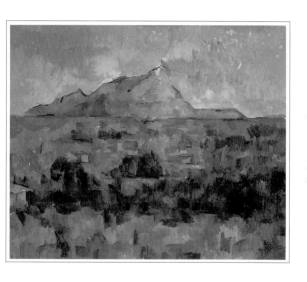

MONET

1 8 4 0 — 1 9 2 6

Monet

Claude Monet (1840-1926) was born in Paris but grew up at Le Havre, at the mouth of the Seine. Both coast and river, close to which he lived throughout his life, were to play a central role in his artistic development. It was at Le Havre that Monet found his first mentors in the local artist Eugène Boudin, who opened his eyes to the possibilities of painting landscapes in the open air, and the Dutch painter Johan Barthold Jongkind, whose fluent style

influenced him profoundly when they painted there together in 1864.

At the studio of Charles Gleyre in Paris, Monet met Sisley, Bazille and Renoir, who were persuaded to join him on painting expeditions to Fontainebleau. By the end of the 1860s, during most of which Monet lived in extreme poverty, he had found that the reaches of the Seine below Paris offered ideal subjects for painting *'directly in front of nature',* and the stretch between Louveciennes and Bougival, where he and Renoir painted together in 1869, is regarded as the birthplace of Impressionism. Although he had already exhibited several times at the Salon, Monet took part in all the Impressionist exhibitions of the 1870s, and was arguably the central figure of the movement. While he

was no theorist, none had greater influence or adhered so consistently to Impressionist precepts.

After seeing out the France-Prussian War in London, where the Thames provided a compelling subject, Monet and his wife Camille lived for most of the decade at Argenteuil. In his river scenes of the period, many of which were painted on the floating studio built for him by the painter Caillebotte, figures and background occupied him less and less as he concentrated on capturing the fleeting effects of light on water.

For many years after Camille's death in 1879 Monet travelled extensively, but returned with ever greater pleasure to his new home at Giverny, to which he had moved in 1883 with Alice Hoschédé, (later to be his

second wife), and where he was creating an idyllic garden. In the 1890s, now finally established as an artist and financially secure, Monet took to producing series of studies of the same object – Poplars, Haystacks, Rouen Cathedral, the Thames – in different light and weather conditions. With the completion in 1899 of the water garden at Giverny, he began the series of paintings of water-lilies which occupied him for most of his last 25 years, and in which a lifetime's development is seen to culminate in virtually abstract studies of pure colour. ◼

View of Rouelles

Oil on canvas
1858
46 × 65 cm

This highly proficient study of the lush Normandy countryside, painted when Monet was seventeen, is one of his earliest surviving landscapes. A painting expedition with Boudin a year or so before had been a revelation – *'My destiny as a painter was decided.'*

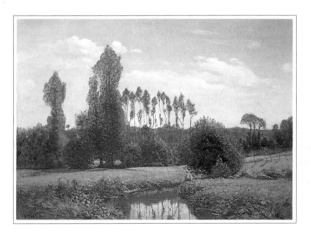

The Hôtel Roches-Noires at Trouville

Oil on canvas
1870
81 × 58.5 cm

In the summer of 1870, with France at war with Prussia, Monet was at Trouville on the Normandy coast, producing rapid studies of his new wife on the beach and painting coastal features such as this luxury hotel. The Monets had chosen more modest accommodation for themselves – but still left without paying the bill.

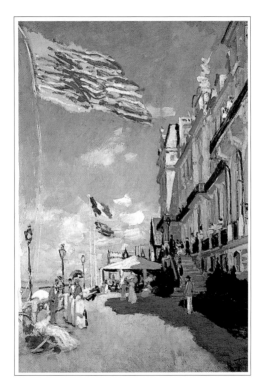

Tulip Fields with the Rijnsburg Windmill

Oil on canvas
1886
65 × 81 cm

Monet first visited Holland in 1871, following his year in England during the Franco-Prussian War, and returned several times in the early 1870 to paint mostly in the area round Zaandam, near Amsterdam. This scene in the tulip fields near Leiden dates from a visit he made in 1886.

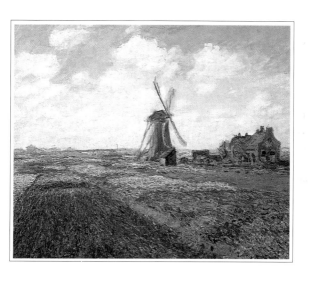

Impression, Sunrise

Oil on canvas
1872
48 × 63 cm

Ironically, since Monet did not care greatly for Turner's work, it was this most Turneresque of his paintings which accidentally gave Monet and his friend their identity. At the first group exhibition of 1874, a hostile critic seized on the title, labelling them all 'Impressionists', and the name stuck.

Overleaf - In 1872 Monet and his family moved to Argenteuil, on the Seine, and over the next few years, a time of contentment and relative prosperity, the river and the surrounding countryside inspired some of his most idyllic paintings. This one has much in common with Renoir's _Path through the Long Grass_.

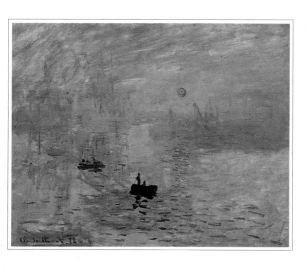

Wild Poppies

Oil on canvas
1873
50 × 65 cm

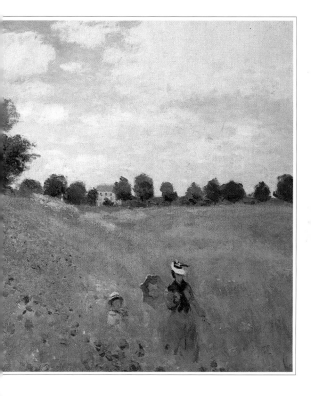

Argenteuil

Oil on canvas
c. 1875
55 × 65 cm

Much of Monet's time during the
Argenteuil years was spent by or on the
river, in all weathers, applying his
spontaneous technique to the
impressions created by water and
reflections under changing conditions
of light. Impressionist colleagues came
to join him, and the movement would
never know such unity again.

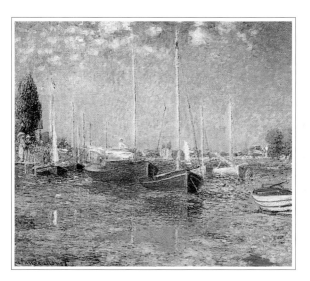

A Woman Reading

Oil on canvas
c.1875
50 × 65.5 cm

Camille Monet posed for this exquisite study in which Monet tackled a subject frequently explored by Renoir: the effect on figures of dappled light through foliage. The Argenteuil idyll was not to last much longer: dire financial difficulty coincided with Camille's illness, and the decade ended in tragedy.

Overleaf – Early in 1877 Monet discovered the poetry of iron, glass and steam at the new St Lazare station. *'This year,'* wrote Emile Zola, *'Monet exhibited some superb station interiors. You can hear the rumbling of the trains as the station engulfs them. You can see the smoke billowing out beneath the vast hangars. That's painting today ...'*

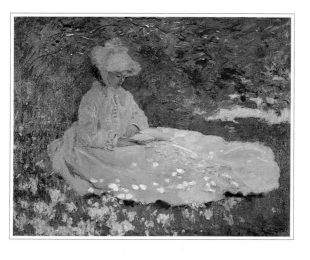

The Gare St-Lazare

Oil on canvas
1877
75 × 100 cm

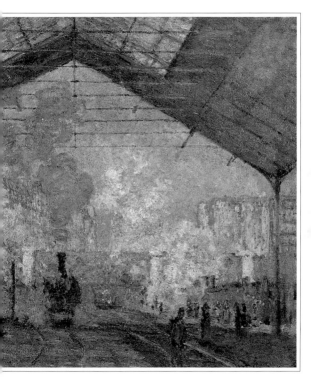

Rue Montorgueil

Oil on canvas
1878
80 × 50 cm

Monet painted this riot of patriotic colour on 30 June 1878, when the first Fête Nationale to be celebrated since the war coincided with the opening of the World Fair. Broad brush-strokes capture the waving tricolour flags and heighten the impression of Paris in joyous movement.

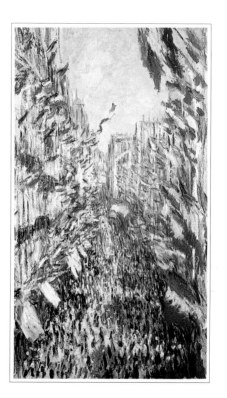

Spring

Oil on canvas
1886
65 × 81 cm

This is an orchard at Giverny, where Monet had settled in 1883, together with Alice Hoschédé, later his second wife, her children and his own. Monet did not at first find much to catch his eye in the placid landscape, but it grew on him. Soon, in any case, his own garden would provide all the inspiration he needed.

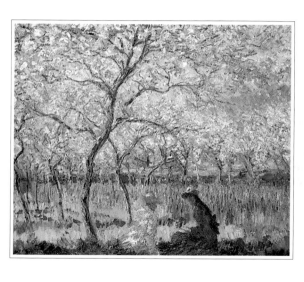

**Woman with a
Parasol, Turned to
the Left**

Oil on canvas
1886
131 × 88 cm

In 1886, possibly in reaction to the
frozen figures of Seurat's *La Grande
Jatte*, Monet undertook a series of
open-air paintings of figures in natural,
spontaneous attitudes. This painting,
one of a pair for which Suzanne
Hoschédé posed, is a re-working of an
earlier work, *Promenade*, for which
Camille had posed in 1875.

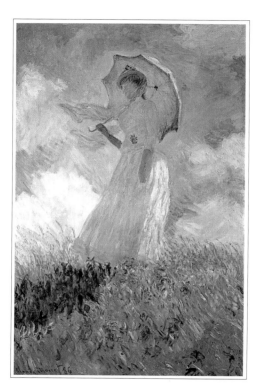

The Rocks of Belle-Ile

Oil on canvas
1886
63 × 79 cm

In 1886 Monet travelled to south-west Brittany and found entirely new subject-matter on the tiny island of Belle-Ile. Often working in wind and rain, he used deep colours and vigorous brush-strokes to capture the violence of the sea and the ferocity of the granite outcrops.

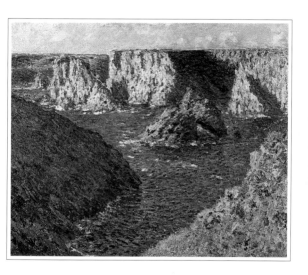

Antibes

Oil on canvas
1888
65 × 92 cm

On his second Mediterranean trip in
1888, Monet spent four months in the
Cap d'Antibes area, where he tried out
new methods of conveying the brilliant
southern light. This view, with its
almost Japanese serenity, demonstrates
his way of unifying a painting by
using the same colours, in different
proportions, in every area of the
canvas.

Haystack at Sunset,
Frosty Weather

Oil on canvas
1891
65 × 92 cm

In 1890 Monet began the first of
several organized series of painting
of the same subject under subtly
changing conditions. In the
Haystacks series, as in *Poplars* and
Rouen Cathedral, the real subject is the
change itself, observed by comparing
the paintings. A remarkable feature
here is the luminous effect achieved
by the juxtaposition of contrasting
colours.

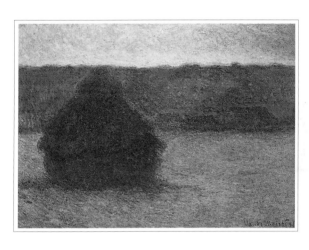

***The Artist's Garden
at Giverny***

Oil on canvas
1900
81 × 92 cm

Giverny provided Monet with his first real chance to create a floral paradise. He designed the garden along formal lines, but planted it so as to create a profusion of colour. *'What I need most are flowers, always, always.'* He never tired of showing visitors around it – and he painted it over five hundred times.

London, Parliament with the Sun Breaking through Fog

Oil on canvas
1904
81 × 92 cm

At the turn of the century Monet went to London three winters in a row and, out of London fog and Gothic architecture, created some of his most mysterious images. Unable to match the speed with which the mists moved, however, he broke his own rule by finishing them at Giverny. *'It's the result that counts,'* he said.

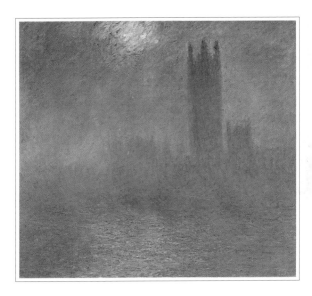

The Boat at Giverny

Oil on canvas

c.1887

98 × 131 cm

This idyllic study of piscatory elegance reflected in the limpid waters of the Epte was painted in the early days at Giverny. A dozen years later Monet's private water paradise would be completed, with the models that would inspire him for much of his last quarter-century spreading silently across its surface.

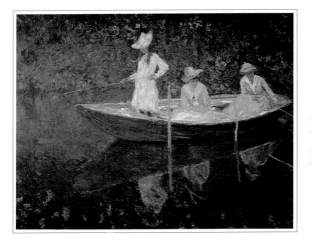

The Water-Lily Pond

Oil on canvas
1900
89.5 × 100 cm

Monet designed his tranquil water garden with the help of a Japanese gardener and diverted the little River Ru to fill his initial pond, which he spanned with a Japanese bridge. The pond was later extended, and the bridge festooned with wisteria. It survives today as the focal point of Monet's living memorial.

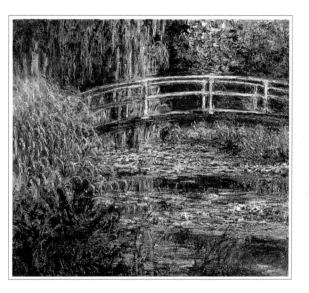

Water-Lilies

Oil on canvas
1904
90 × 93 cm

Monet always insisted that the inspiration for his final and most famous series took him unawares: *'I planted my water-lilies for pleasure. I cultivated them without thinking of painting them. A landscape does not get through to you all at once. And then, suddenly, I had the revelation of the magic of my pond.'*

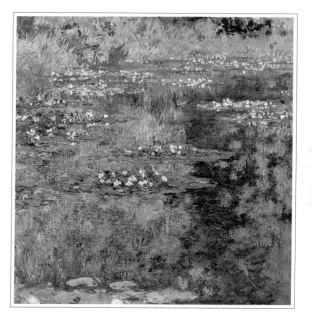

RENOIR

1 8 4 1 — 1 9 1 9

Renoir

Auguste Renoir (1841-1919) had a more down-to-earth attitude to art than many of his contemporaries, and always saw himself as a craftsman. At the age of thirteen he was apprenticed to a porcelain painter and later supported himself by taking on decorative commissions, while spending as much time as possible at the Louvre, studying French masters such as Fragonard and Boucher. It was not until 1861 that he could just afford to enter the studio of Charles

Gleyre, where he met Monet, Sisley and Bazille, and through them Courbet and Pissarro.

Soon Renoir was applying Impressionist techniques to portraits and nudes, as well as outdoor scenes, and under the influence of Monet his work became considerably lighter and freer. He and Monet would work together beside the Seine, often painting the same subjects in remarkably similar styles. Renoir took part in the first three Impressionist exhibitions, where he had more success than most, and in his paintings of Parisians disporting themselves in the open air he created some of the most archetypal images of the Impressionists' world. Soon, however, he was not only obtaining portrait commissions but, from 1877, exhibiting regularly at the Salon.

This did not endear him to some of his colleagues in the movement, but by the early 1880s, following visits to Italy and renewed attention to the eighteenth-century masters, he was in any case coming to the conclusion that for him the concerns of Impressionism were a dead end, and that *'the only worthwhile thing for a painter is to study in the museums'*. He began to concentrate almost entirely on human figures, painted in brilliantly luminous colours, and his later subjects were mostly female nudes, which both delighted his eye and suited his palette. Even in his final years at Cagnes, on the Mediterranean, crippled with arthritis and barely able to paint – he would have the brush strapped to his wrist – his work lost none of its warmth and serenity.

At his best, Renoir is one of the greatest ever painters of the human form. If on occasion his treatment of a child can appear idealized, or a nude over-ripe, this is simply because he wàs entranced by the play of light on glowing, healthy skin. *I always want to paint people as if they were luscious fruit.* He was an uncomplicated man who had his share of hardship in the early days but enjoyed life, loved his work, and had little time for agonizing or for theories. *The ideas come afterwards,* he said, *when the picture is finished.* ◾

Portrait of Lise

Oil on canvas
1867
181 × 113 cm

Renoir's painting of his young mistress,
Lise Tréhot, in the Forêt de
Fontainebleau is arguably his first great
painting. The influence of Courbet still
shows, but delicate touches such as the
half-shadow on the face are pure
Renoir. It was exhibited at the Salon
in 1868.

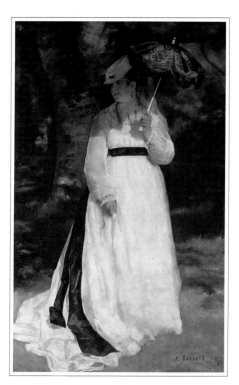

The Path through
the Long Grass

Oil on canvas
1873
60 × 74 cm

This delightful evocation of an outing
in high summer, painted near
Argenteuil, has much in common with
Monet's _Wild Poppies_ both in
atmosphere and composition, notably
the ploy of using a repeated pair of
figures to provide a sense of movement
and depth.

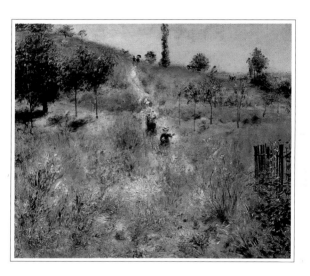

Moss Roses

Oil on canvas
c.1890
35.5 × 27 cm

Renoir produced numerous studies of flowers during his Impressionist period. He enjoyed painting them and continued to do so, frequently incorporating them into his large compositions for decorative effect.

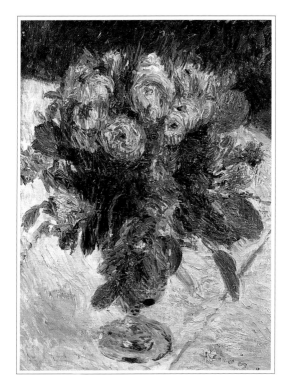

***Girl with a
White Hat***

Oil on canvas
c.1892
41 × 33.5 cm

Renoir loved to paint his friends, and
by the mid 1870s his reputation as a
portrait painter was growing. Lucrative
portrait commissions gave him the
freedom to take on more ambitious
projects.

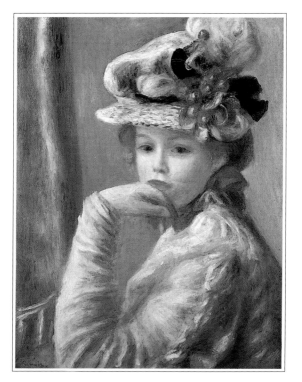

**On the Banks of the
Seine at Champrosay**

Oil on canvas
1876
55 × 66 cm

After spending summers with Monet
at Argenteuil, Renoir was on the Seine
once again when he stayed at the home
of the novelist Alphonse Daudet, who
had commissioned a portrait of his wife.
There he met Georges Charpentier,
who became an important and
influential client.

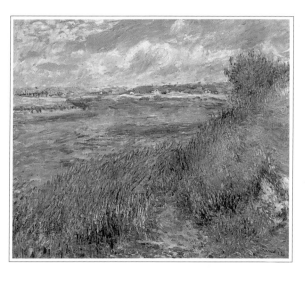

In the Garden

Oil on canvas
1875
81 × 65 cm

Even at this early stage of his career Renoir was tending to populate his outdoor scenes with figures, which he handled with great naturalness. It was his predilection for painting the human form which would lead him, as time went on, to grow increasingly dissatisfied with Impressionism.

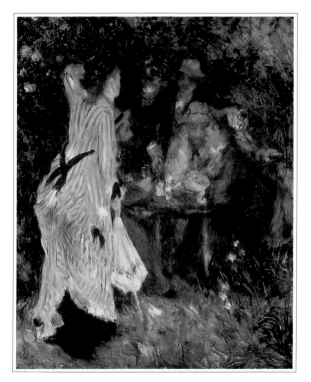

The Swing

Oil on canvas
1876
92 × 73 cm

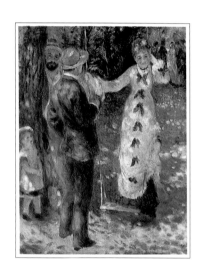

Left – Painted in the garden of the house rented by Renoir in the Rue Cortot in Montmartre, this ravishing study in dappled sunlight has great depth and an engaging group of figures. When it was exhibited at the third Impressionist exhibition the following year, critics described it as *'audacious'.*

Overleaf – One of the archetypal images of the Impressionist era, this is also a monument to the principle of painting directly from nature on the spot. Day after day, Renoir brought the enormous canvas back to the open-air dance floor, with the help of friends who also posed for the main figures.

*Dancing at the
Moulin de la Galette*

Oil on canvas
1876
131 × 175 cm

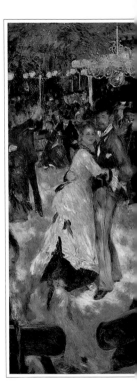

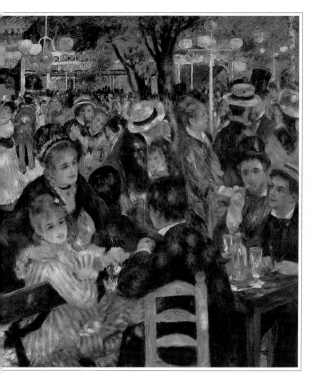

The First Evening Out

Oil on canvas
1876 – 7
65 × 51 cm

This sensitive study represents the perfect marriage of genre subject with Impressionist technique. True to the principle of showing only what the eye sees at a given moment, Renoir leaves the entire background indistinct and focuses purely on the girl's face, thus emphasizing her nervous excitement.

Countryside at Berneval

Oil on canvas
1879
49 × 61.5 cm

Renoir returned several times to Berneval following his first trip to the Normandy coast in 1879. Although rugged coastal scenes did not appeal to him as subject-matter as much as to Monet and others, he appreciated the light and produced some memorable landscapes.

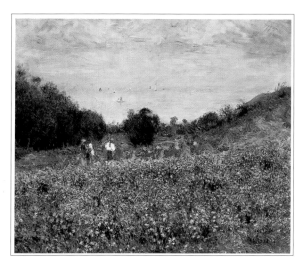

The Rowers' Lunch

Oil on canvas
1879 – 80
55 × 66 cm

The technique is still Impressionist, and indeed the boating scene in the background recalls Renoir's earlier work on the river, but by putting the emphasis on the figures and their pronounced mood of relaxed satisfaction, Renoir seems already to be distancing himself from the abstract values of Impressionism.

Overleaf - In this carefree scene at the Restaurant Fournaise on the Ile de Chatou, only the sketchy background is truly Impressionist, while the treatment of the figures is more or less conventional. Moreover it was painted in the studio. Seated on the right is Gustave Caillebotte; on the left, Aline Charigot, whom Renoir would marry.

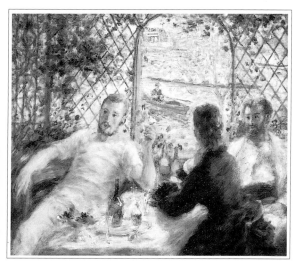

*Luncheon of the
Boating Party*

Oil on canvas
1881
130 × 173 cm

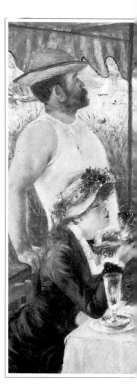

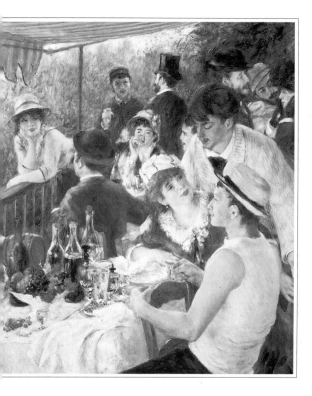

Dancing in the Country

Oil on canvas
1883
180 × 90 cm

A more rounded Aline posed for this, the most relaxed and cheerful-looking of three very similar dance compositions, all of which Renoir painted in the same year.

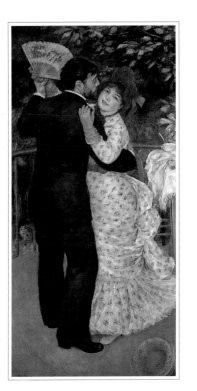

Bather, Seated

Oil on canvas
1882 – 3
54 × 39 cm

Renoir's travels in the 1880s hardened his attitude to the shortcomings of Impressionism. Turning again to the painters of the seventeenth and eighteenth centuries, he became increasingly preoccupied with painting the female form. This figure, isolated against the blue background, has a truly classical serenity.

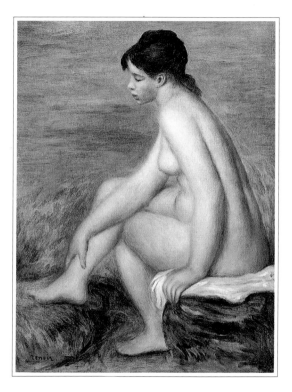

Woman Drying her Feet

Oil on canvas
c.1888
65.5 × 54.5 cm

After experimenting during the 1880s with his *manière aigre*, or sour style, characterized by bleached colours, precise contours and a somewhat artificial decorativeness, Renoir has returned to the full range of lush colours for this sublimely natural woodland idyll.

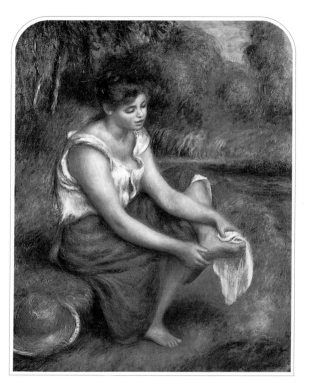

Bather, Standing

Oil on canvas
1896
81 × 61 cm

*'I have a horror of the word "flesh", which
has become so shop-worn. Why not "meat"
while they are about it? What I like is skin,
a young girl's skin that is pink and shows
that she has good circulation.'* – Renoir

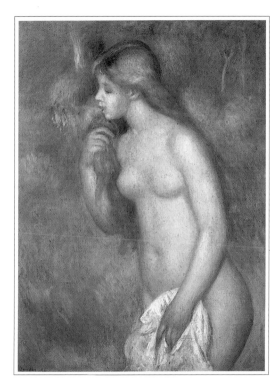

**Bather Arranging
her Hair**

Oil on canvas
1893
922 × 739 cm

In this nude there is a remarkable sense
of movement and life which, combined
with the warm colours, produced a
really satisfying, sensuous production
in the Titian tradition.

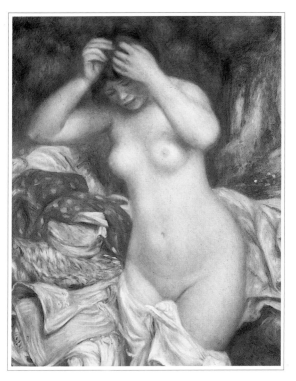

***Blonde Girl
Combing her Hair***

Oil on canvas
1894
56 × 46 cm

By nature the most relaxed and
optimistic of his contemporaries,
Renoir was a life-enhancing figure, the
best of whose later work is a subtle and
vibrant hymn to feminine beauty.

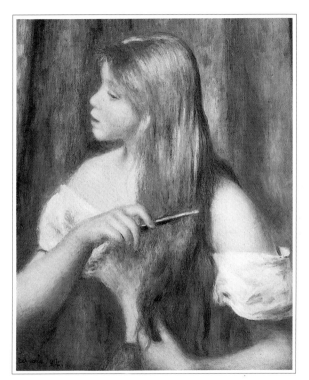

Breakfast at Berneval

Oil on canvas
1898
81.2 × 66 cm

This family scene, painted at a house that Renoir had rented on the Normandy coast, shows his two sons, Pierre, reading, and Jean, the future film director, in discussion with a relative.

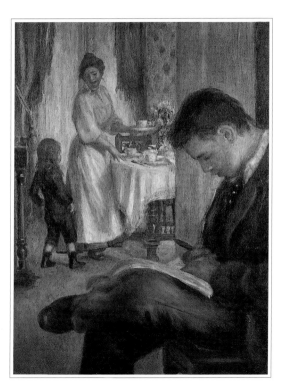

ROUSSEAU

1844 – 1910

Rousseau

Henri Rousseau (1844-1910) was just four years younger than Claude Monet and in time became friendly with several of the Impressionists, but his work bears virtually no trace of influence from his famous contemporaries. As a character and as an artist he was wholly original.

Rousseau was born in Laval, in north-west France, where his father was a tinsmith. After showing early promise in music and drawing he spent five

years in the army, but the story that he served in Mexico appears to be a myth. In 1871, by now married, Rousseau obtained a junior post in the Paris customs service and spent the next twenty years manning toll stations around the outskirts of Paris – hence his affectionate nickname 'Le Douanier'. In his spare time he took to painting surburban scenes, and by 1884 he had a permit to copy paintings at the Louvre and other museums.

As a painter Rousseau was entirely self-taught, and the naïve style of his four submissions to the 1886 Salon des Indépendants (the year of Seurat's *La Grande Jatte*) caused derisive laughter which never completely subsided. Even then, however, not everyone mocked. Several critics compared him to the Italian primitives,

and Pissarro, struck by Rousseau's skilful handling of colour, became an early supporter. Thereafter he exhibited at every Salon des Indépendants until his death, a breakthrough occurring in 1891 when *Surprise! Tropical Storm with Tiger* inspired the first serious review of his work. *'There is always something beautiful,'* the critic wrote, *'about seeing a faith, any faith, so pitilessly expressed.'*

Rousseau's wife had died in 1886, and of their seven children only two had survived. He married his second wife in 1899, but four years later was again a widower. To supplement his pension he was now giving tuition in music and painting, and had written two plays. (He also became innocently involved in a minor fraud, for which he spent several weeks in prison.) Meanwhile,

through his friendship with the young playwright Alfred Jarry, Rousseau had met other writers and become something of a mascot in literary and artistic circles. 'Le Douanier' may have been a good joke, but they were in no doubt about his genius.

Far from being a Sunday painter, Rousseau was dedicated to his art and a perfectionist. He planned and executed his paintings with meticulous care, and became highly skilled both in composing his canvases and in creating subtle harmonies of colour within a carefully controlled overall scheme. It is Rousseau's unique vision, however, his engaging blend of innocence and theatricality, magically conveying a sense of the mystery and wonder of the world, that makes him the greatest of the modern primitives. ◢

The Toll House

Oil on canvas
c.1890 – 1
37.5 × 32.5 cm

Rousseau not only found poetry in his mundane former workplace at the Porte de Vanves but idealized it with a harmonious rural setting. However, there is something about the deliberate placing of spire, chimneys, lamp post and trees - and indeed the *douaniers* - that makes the atmosphere unsettling.

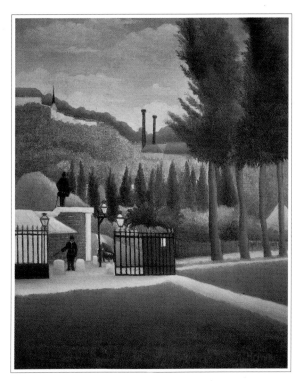

Surprise! Tropical Storm with Tiger

Oil on canvas
1891
130 × 162 cm

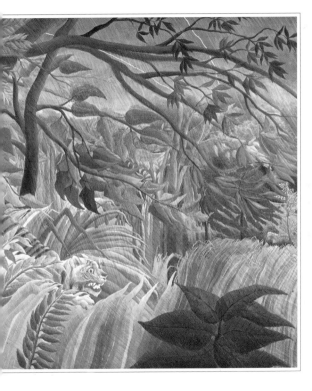

Previous page – By far the earliest of Rousseau's jungle paintings, *Surprise!* is also unique in being filled with tempestuous movement. Exhibited at the 1891 Salon des Indépendants, the painting inspired the first respectful review of Rousseau's work, which referred to his *'self-sufficiency and childlike naïveté'.*

War

Oil on canvas
1894
114 × 195 cm

In Rousseau's most dramatic and allegorical painting, this grotesque figure on her somewhat reptilian black horse is war personified, galloping over dead and mutilated men. As Rousseau wrote in the Salon des Indépendants catalogue, *'She passes, terrifying, leaving all around her despair, tears and ruins.'*

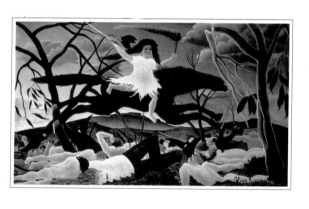

The Cliff

Oil on canvas
c.1895
21 × 35 cm

Although influences are seldom
detectable in Rousseau's work, here, as
in *The Toll House,* the strong vertical
and horizontal lines are reminiscent of
Seurat. The subject, too, is unusual for
Rousseau, who seldom ventured far
from Paris, and whose figures, unless a
prey to wild animals, are almost always
posed.

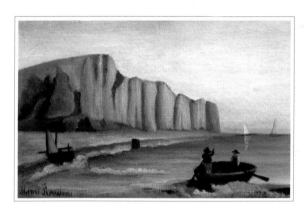

The Watermill

Oil on canvas
c.1896
31.8 × 54.6 cm

Unlike the Impressionists, whose work includes few references to the spread of industry, Rousseau would happily paint mills, quarries and factories and positively revelled in new inventions. This is one of several paintings of mills on the outskirts of Paris.

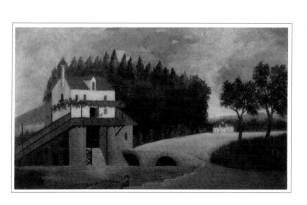

Portrait of a Woman

Oil on canvas
c.1895 – 7
198 × 115 cm

Rousseau specialized in painting figures in garden or jungle settings, of which this is one of the more conventional examples. The degree of finish in the delicately painted flowers and framing foliage, as well as in the charming kitten, suggests that this was one of his more lucrative commissions.

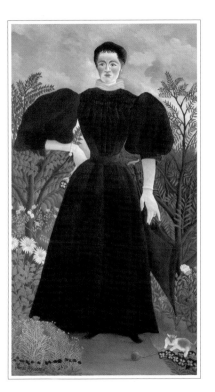

Bouquet of Flowers

Oil on canvas
c.1895 – 1900
61 × 50 cm

Most of Rousseau's rare still-lifes are
of flowers. Here each leaf and flower is
seen head on, creating a childlike two-
dimensional effect. Once again the
pansies, here peering out like the furry
heads of jungle beasts, are painted with
especially loving precision.

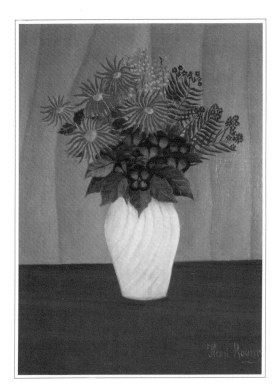

**The Banks
of the Oise**

Oil on canvas
c.1905 – 6
46 × 56 cm

If the subject-matter is firmly
Impressionist, the mood is anything
but. This unusually rural scene owes its
eerie atmosphere to the dim lighting
and the strange *culs de sac* out of which
sail the crowded and gaudily tricolor
boats.

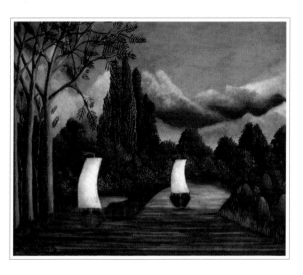

Jungle with a Woman in Red

Oil on canvas
c.1905 – 10
75 × 59 cm

For once there are no fierce creatures gazing out of Rousseau's monstrously magnified vegetation, and the sense of menace stems from his surrealist juxtaposition of city sophistication and jungle wildness. The figure looks rigid, but perhaps less from fear than from formality, as she is probably based on a fashion plate.

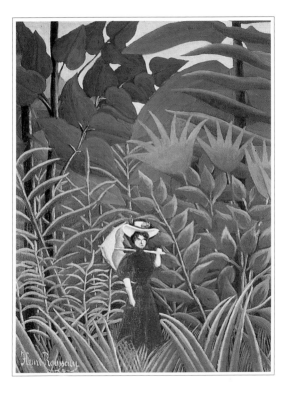

Representatives of Foreign Powers Come to Salute the Republic as a Token of Peace

Oil on canvas
c.1907
130 × 161 cm

Rousseau's republican sympathies are given free rein in this ambitious work which was bought by Picasso. No such gathering of heads of state took place, and international recognition of the Third Republic was in fact slow in coming. This fervently patriotic scene is presumably Rousseau's version of what should have been.

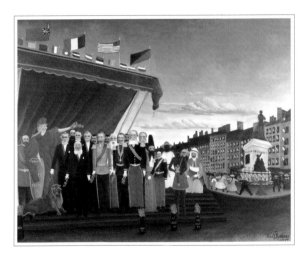

The Snake Charmer

Oil on canvas

C.1907

169 × 189 cm

One of Rousseau's masterpieces, *The Snake Charmer* is the antithesis of *War* in composition, colouring, mood and content. Here nothing disturbs the tranquillity, and all live in harmony in what may be seen as a lost paradise, peopled perhaps by the 'noble savage' of Rousseau's eighteenth-century namesake, the philosopher Jean-Jacques Rousseau.

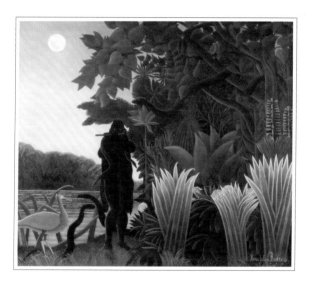

*View of the Pont
de Sèvres*

Oil on canvas
c.1908
81 × 100 cm

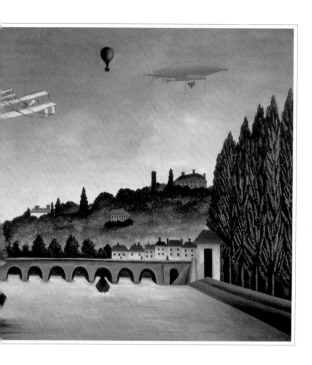

Previous page – Rousseau's most ambitious and perhaps most successful landscape, thanks to its subtle handling of colour, also shows his delight in depicting new inventions. The aeroplane and the dirigible were late additions, with no loss of harmony to the composition.

View of Malakoff, Hauts-de-Seine

Oil on canvas
c.1908
46 × 55 cm

Rousseau would find beauty in what others saw as ugly modern intrusions into the landscape. This painting, perhaps the most extreme example with its dominant telegraph poles and wires – and insulators looking rather like seed-heads – was among those included by Kandinsky in the 1912 *Blaue Reiter* almanac.

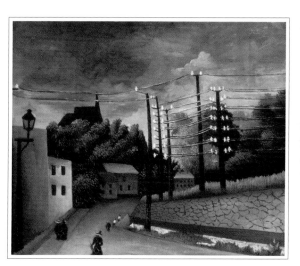

Fight between a Tiger and a Buffalo

Oil on canvas
c.1908
46 × 55 cm

While the composition is similar to that of *Surprise!*, notably the position of the tiger, the jungle itself has changed. Here it has a dreamlike immobility, enhanced by the straight verticals, and broken only by the sudden bout of savagery. For all its sumptuous beauty, the jungle is still a violent place.

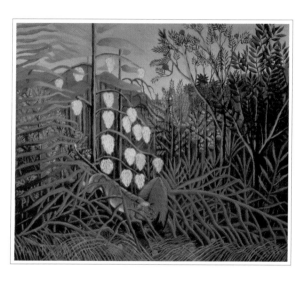

The Poet and his Muse

Oil on canvas
c.1908 – 9
131 × 97 cm

The poet Apollinaire commissioned this portrait of himself with the artist Marie Laurencin, whose actual slim figure presumably looked inappropriate to Rousseau. Apollinaire regarded Rousseau as a genius and championed him in verse, but unfortunately was equally hard up and never managed to pay for the painting.

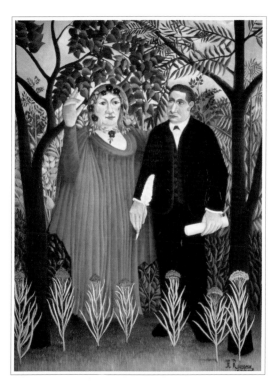

*The Cascading
Gardens*

Oil on canvas
C.1909
33 × 41 cm

Here is a charmingly naïve treatment
of a sophisticated eighteenth-century
theme – smartly dressed strollers in
the Jardin du Luxembourg, where
Rousseau also painted the background
for his portrait of Apollinaire and
Laurencin. Both paintings were
eventually sold by Ambroise Vollard
to the great Russian collector Sergei
Shchukin.

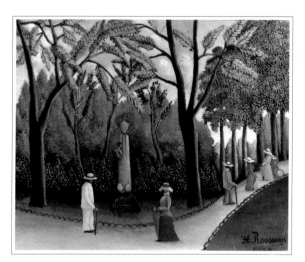

The Waterfall

Oil on canvas
c.1910
115 × 151 cm

Previous page – Rousseau's jungle is nowhere more peaceful than in this idyllic scene near a native village, with man and beast co-existing happily. As in *The Snake Charmer*, the presence of water seems to lend harmony to an environment elsewhere depicted by Rousseau as a place of beauty but also fraught with danger.

Exotic Landscape

Oil on canvas
c.1910
129 × 162 cm

After his death it emerged that Rousseau's jungle creatures were based on illustrations in a children's book. Nevertheless they always look wholly original, not least these wacky monkeys shaking oranges off a tree while the central figure, who is catching fruit lying on his back, is almost entirely hidden.

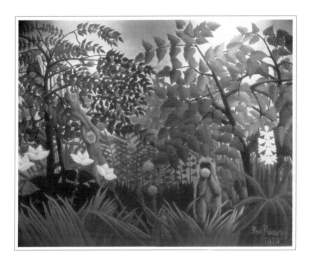

The Dream

Oil on canvas
c.1910
204 × 298 cm

This eerie moonlit scene, in which a dreaming woman is transported into a dark jungle where ferocious beasts are magically held in thrall by the music from the charmer's pipe, is the largest and arguably most wondrous of all the haunting visions of this unique artist.

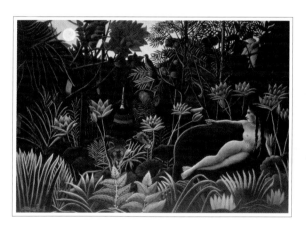

VAN GOGH

1853 – 1890

Van Gogh

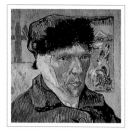

Vincent van Gogh (1853-1890) only found his true vocation in 1880, a mere ten years before his death, but he brought to his study of painting the same fervour that he had shown as a lay preacher. At the end of five years of hard and largely self-taught apprenticeship in Holland, during which he struggled with technique – and with the poverty that he would never shake off – he achieved some mastery of oils in a series of assured if sombre paintings of peasant life.

In 1886, at the suggestion of his brother Theo, he came to Paris where he met some of the Impressionists, broadened the scope of his subject-matter, lightened his palette and experimented briefly with the techniques of the pointillists and Japanese printmakers.

When, oppressed by city life, Vincent headed off to Provence in 1888 with the dream of setting up an artists' colony there, he told Theo that he wanted to paint like a Japanese artist. The dream was shattered when a three-month visit by Gauguin ended disastrously with Vincent's first breakdown, but he painted more and more like a man possessed: portraits, still-lifes, interiors, self-portraits and, above all, the drama of the landscape. In a feverish adaptation of the pointillists' technique he laid his

colours out in ribbons, sometimes even squeezing it straight from the tube on to the canvas in his hurry to express his burning vision of nature and its magic, in which the tortured cypresses and dazzling sunflowers began to seem like sacred motifs.

Tormented by hallucinations as well as sheer loneliness, Vincent admitted himself to the mental hospital at St Rémy, where for a year he found some relief and was able to paint intermittently with increasing power. In May 1890, however, he discharged himself and returned north. He seemed to have found tranquillity under the care of Dr Gachet at Auvers, although the paintings of this brief period suggest otherwise. On 27 July, in the grip of despair, he shot himself, and died two days later.

Heartbreaking as the story of this passionate misfit is, his immortality at least is assured. It is a sobering thought that, had his struggle ended a mere two years earlier, before he moved to Arles and there, supported from afar by the love, encouragement and financial help of his admirable brother, gloriously fulfilled himself as a painter, he would now be regarded as a sad peripheral figure, and not as the tragic giant of nineteenth-century art. ◼

Landscape in Brabant

Oil on canvas
1885
22 × 37 cm

This early landscape, probably painted
at Nuenen, is far removed from the
bold, passionate canvases of the Arles
period. Nevertheless the gloomy
atmosphere of the drab terrain is
effectively conveyed.

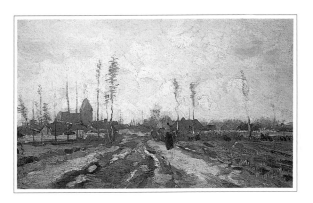

The Weaver

Oil on canvas
1884
37 × 45 cm

Vincent's spell as a lay missionary in Belgian mining communities had made him highly sympathetic to the labouring classes. The weaver, surrounded by his apparatus, made him think of *'prisoners in I know not what horrible cage'*.

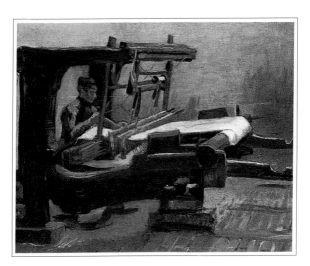

**Peasant Woman
from Nuenen**

Oil on canvas
1885
45 × 27 cm

Left – During his Dutch period Vincent found most of his subject-matter in the lives of peasants, whom he painted with grave dignity. Their back-breaking work in the fields would remain a compelling theme until the end of his life.

Overleaf – The subject of this early drawing, one of a series depicting the four seasons, appealed strongly to Vincent as an allegorical symbol of renewal. He would return to it in his St Rémy period in his reworking of Millet's painting.

The Sower

Pencil and pen
1884
6 × 14 cm

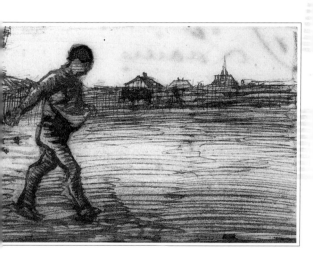

Fishing in the Spring

Oil on canvas
1887
49 × 58 cm

Early in 1886 Vincent arrived in Paris, where for two years he was bombarded with new ideas and experiences – chiefly, through his friendship with painters such as Paul Signac, the revelation of neo-Impressionist ideas about colour and light. Here he is experimenting with dabs of paint.

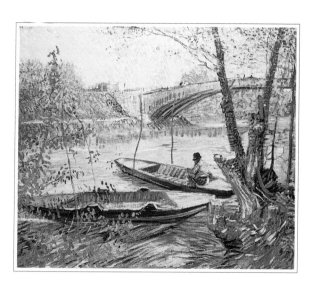

***A Wheatfield
with a Lark***

Oil on canvas
1887
54 × 64.5 cm

This animated canvas from the Paris
period, with its golden stubble,
swaying corn and agitated sky, seems
strangely prophetic of the style and the
storms to come when Vincent moved
to Provence.

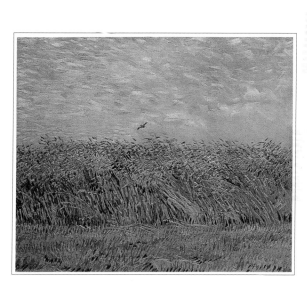

Sunflowers

Oil on canvas
1887
43 × 61 cm

The sight of sunflowers in a Parisian window struck Vincent so forcibly that they became an obsession – and his most popular and distinctive subject. He painted them many times, racing to complete each canvas in one sitting before the flowers wilted.

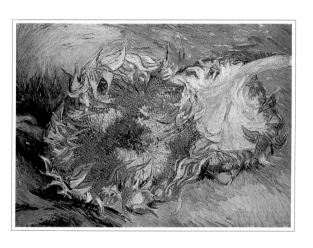

**Pollard Willows
and Setting Sun**

Oil on canvas
1888
31 × 34 cm

Paris had opened Vincent's eyes to
colour, but now he wanted more of it –
pure colour – and in Provence he
found it. *'The pale orange of the sunsets
makes the fields appear blue,'* he exclaimed
in a letter to Emile Bernard from Arles.
'The sun is a splendid yellow'.

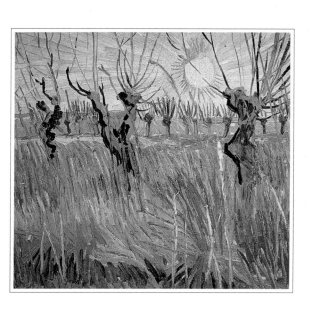

***The Promenade
of the Alyscamps***

Oil on canvas
1888
92 × 73.5 cm

At Arles, Vincent found a compelling,
if untypical subject in the site of a vast
Roman burial ground, of which this
avenue is virtually all that remains.
Vincent was struck by the atmosphere
of the place and painted it several
times.

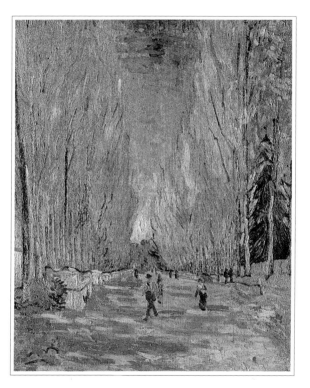

**Sunday Evening
at Arles**

Oil on canvas
1888
74 × 91 cm

The harsh, brilliant colours of the
south had an overwhelming effect on
Vincent, who described himself as
working in a frenzy. The result was an
intensity of colour, such as this yellow,
that had never been painted before.

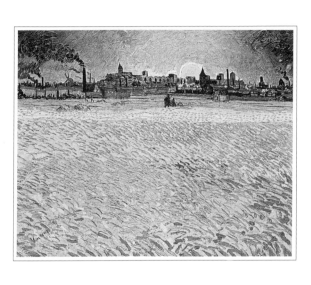

La Mousmé

Oil on canvas
1888
74 × 60 cm

After a few months of painting the Provençal landscape, Vincent began to find time for portraits. The title of this charming study of youth is a Japanese word meaning young girl, which he borrowed from a Pierre Loti novel.

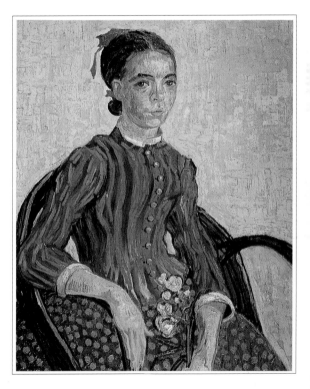

Sunflowers

Oil on canvas
1888
91 × 72 cm

In August 1888 Vincent began what was to become a sublime series of paintings of his beloved sunflowers, with which he planned to decorate his studio. _'I am hard at it,'_ he wrote to Theo, _'painting with the enthusiasm of a Marseillais eating bouillabaisse'._

Overleaf - A night sky such as this had already been described in a letter to Theo: _'In the blue depth the stars were sparkling, greenish, yellow, white, rose, brighter, flashing more like jewels, than they do at home – even in Paris: opals you might call them, emeralds, lapis, rubies, sapphires.'_

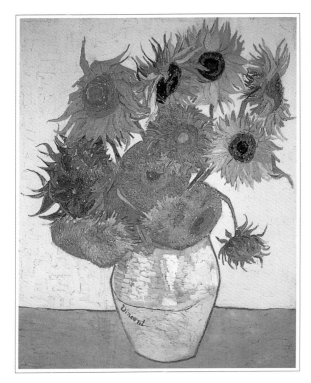

The Starry Night

Oil on canvas
1888
72.5 × 92 cm

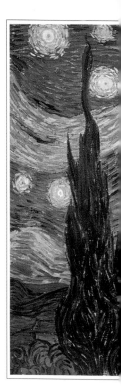

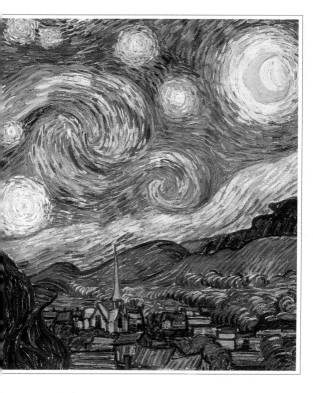

**The Dance Hall
at Arles**

Oil on canvas
1888
65 × 78.5 cm

The dazzling yellow of sunflowers and
the fierce Provençal sun is the hallmark
of Vincent's Arles period. Even this
indoor scene is dominated by flat areas
of yellow, perhaps influenced by
Gauguin, whose ill-fated collaboration
was to be the only one at Vincent's
'studio of the south'.

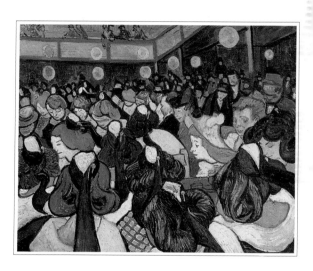

Portrait of Dr Rey

Oil on canvas
1889
64 × 53 cm

When Vincent was admitted to the
hospital at Arles following his
breakdown he was lucky to be under
the supervision of Dr Félix Rey, who
not only showed him kindness but
recognized his genius. Friends of the
young doctor who saw this
sympathetic portrait many years later
said that it was a very good likeness.

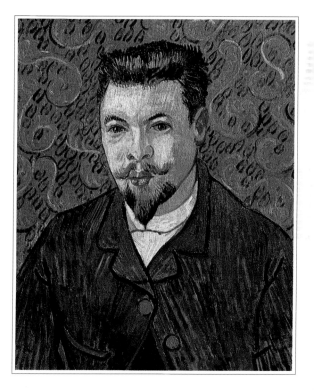

St Paul's Hospital, St Rémy

Oil on canvas
1889
63 × 48 cm

During his time as a mental patient at St Rémy, Vincent suffered attacks which lasted for a week or more. When he was able to paint, his work would be frenzied or relatively calm, according to his state of mind.

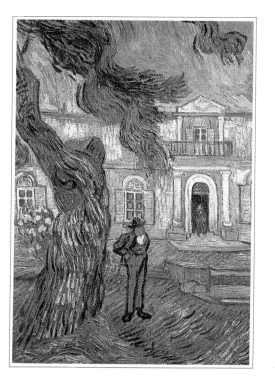

**The Prison
Court-Yard**

Oil on canvas
1890
80 × 64 cm

At the St Rémy asylum Vincent
sometimes set himself the instructive
and, for him, consoling task of copying
works by painters he admired, such as
the *Pieta* by Delacroix. The choice of
Gustave Doré's drawing of the exercise
yard at Newgate Prison had an
altogether grimmer symbolism.

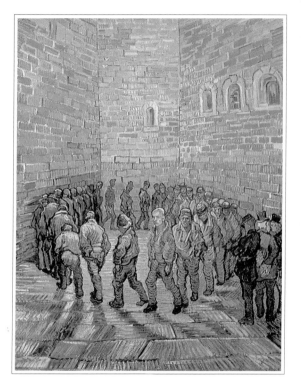

Portrait of
Dr Gachet

Oil on canvas
1890
66 × 57 cm

A friend of Pissarro and Cézanne,
Dr Paul-Ferdinand Gachet treated
Vincent at Auvers-sur-Oise during the
final weeks of his life, and encouraged
him to resume painting. Following the
shooting he tried unsuccessfully to
save Vincent's life.

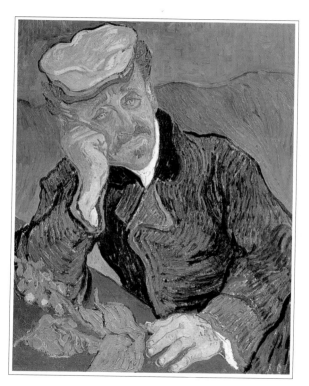

The Church at Auvers

Oil on canvas
1890
94 × 74 cm

Although Vincent described the content of the painting in measured terms in a letter to Theo, its deformed lines are strongly suggestive of mental turmoil. Whatever the final straw was that drove him to suicide, he died believing himself to be a burden to others and a failure as an artist.

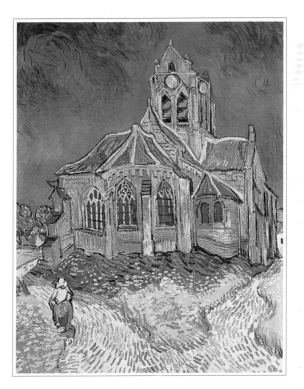

SEURAT

1859 — 1891

Seurat

Georges Seurat (1859-1891) was at the forefront of the generation of painters which followed the Impressionists and whose work reflected the discoveries of Impressionism but marked a radical departure from it in the methods they used.

Born in Paris, Seurat entered the Ecole des Beaux-Arts in 1878, where he was trained in the classical manner by Henri Lehmann, a pupil of Ingres. Other powerful and starkly

contrasting influences were the romanticism of Delacroix and the huge canvases and murals of Puvis de Chavannes, as well as theoretical writings on aesthetics and optical phenomena. Soon Seurat was working on his own theories of colour and vision, which would lead to the technique known as divisionism, or pointillism. This consists of dividing colours into pure pigments and juxtaposing tiny dots of pure colour which, if seen from the correct distance, are blended into secondary tones by the eye of the viewer.

The desire to capture the sensations received from the subtle effects of light was an obsession inherited from the Impressionists, whose fourth exhibition in 1879 made a strong impact on Seurat. However, whereas they tried to achieve it on the spot,

with rapid brush-strokes fluently applied to a small canvas, he chose a much more formal, disciplined, almost scientific approach, of which divisionism was only a part. His compositions were planned in minute detail, with all their elements carefully managed, and details would be rehearsed in numerous preparatory studies before being transferred on to the canvas in his studio in the traditional manner. The result, particularly in Seurat's large-scale depictions of Parisians at leisure in the open air, is a curiously static, trance-like atmosphere which could hardly be further removed from the spontaneity of Impressionism.

By 1886 Seurat was the acknowledged leader of the group of painters, including Paul Signac, who were known as the neo-Impressionists.

Even Impressionists were drawn into it, notably Camille Pissarro, who experimented at length with divisionism in the late 1880s before rejecting it as too laborious and cerebral for his purposes. It was left to other members of the group to pursue the discoveries made by Seurat, for he died suddenly of diptheria at the age of 31. Others, indeed, have claimed some of the credit for them, but it was undoubtedly the intellectual Seurat who formulated the basic theories of divisionism, and although he was prevented from developing them, it can fairly be said that in a career lasting little more than ten years he had accomplished the remarkable feat of creating an entirely new and self-contained system of painting. ◪

The Gleaner

Conté crayon
1881 – 2
31.4 × 23.7 cm

The opposition of light and dark in the drawings which Seurat produced in his early twenties suggests that he may, like van Gogh, have been influenced by Millet. He would continue to use conté crayon in his preparatory sketches for major paintings such as *The Bathers*.

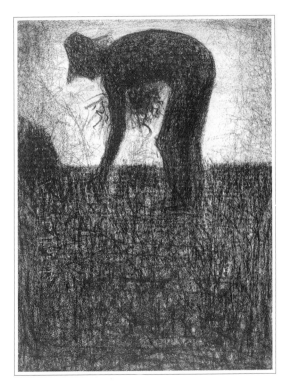

The Stone-breaker

Oil on panel
1882
16.2 × 25.5 cm

In the paintings of agricultural
labourers which Seurat produced in
the period following the fourth
Impressionist exhibition, he gave his
figures strong physical presence and
sometimes, as here, showed them in
vigorous activity. Figures were to have
a much less animated role in his later,
divisionist work.

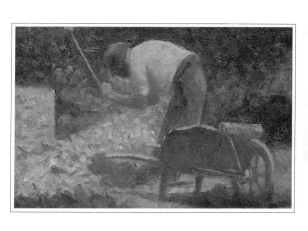

A Field in Summer

Oil on canvas
1883
16 × 25 cm

Seurat found subjects for many of his early landscape paintings in the countryside around Le Raincy, to the east of Paris, where his reclusive father had a second home and spent most of his time, while the family lived in the city.

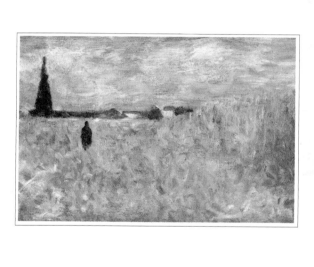

Sunset

Oil on canvas
1881 – 2
15.7 × 25 cm

Of the Impressionists whose work
Seurat saw in the 1870s, it was Pissarro
who provided most encouragement.
He became not only a close friend of
Seurat but also, for a time, a follower.
His recruitment of Seurat and Signac
for the eighth Impressionist exhibition
of 1886 led to Monet, Sisley and Renoir
staying away.

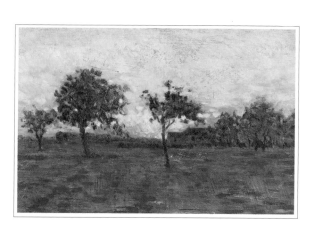

Man Leaning on
a Parapet

Oil on canvas
c.1881 – 2
25 × 16.2 cm

Except for the leaning figure and the carefully related tree, all detail has been eliminated from a composition which anticipates Seurat's later work in its flat horizontals and its tendency towards abstraction.

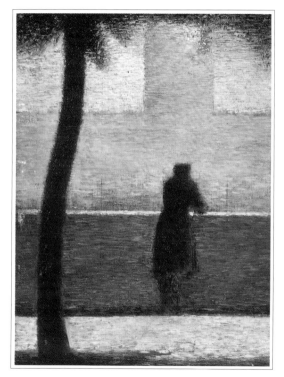

The Watering Can

Oil on panel
c.1883
24.8 × 15.5 cm

Seurat liked to take the kind of object which would normally appear as a detail and place it firmly in the foreground as an integral part of the design. The watering-can was painted at his father's garden at Le Raincy.

**The Bathers at
Asnières**

Oil on canvas
1883 – 4
201 × 301 cm

Seurat's first great work, *The Bathers*,
marks his point of departure from
Impressionism. The popular bathing-
place is essentially Impressionist
subject – matter, but the orderly placing
of the elements and the monumental
stillness are very much his own. He
produced studies of various possible
elements – including horses – before
working out their spatial relationships.

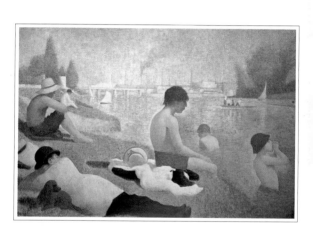

Couple Walking
Study for *Sunday
Afternoon on the Ile de
la Grande Jatte*

Oil on canvas
1884 – 5
81.5 × 65.2 cm

Left – Seurat's work on *La Grande Jatte* coincided with the formulation of his divisionist technique. As a result, although the finished painting became the first major divisionist work to be exhibited, preparatory studies such as this one still have some of the spontaneity of Impressionism.

Overleaf – The fact that some have seen in this gallery of promenading Parisians ironic social comment that Seurat himself disclaimed, is probably due to his meticulous planning and revolutionary divisionism, which combine to produce an artificial, frieze-like effect. Exhibited at the 1886 Impressionist exhibition, Seurat's masterpiece caused a sensation.

Sunday Afternoon on the Ile de la Grande Jatte

Oil on canvas
1884 – 6
207 × 308 cm

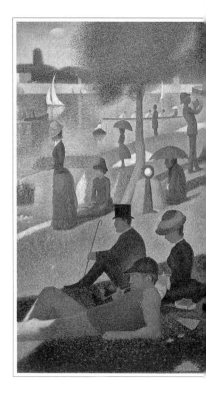

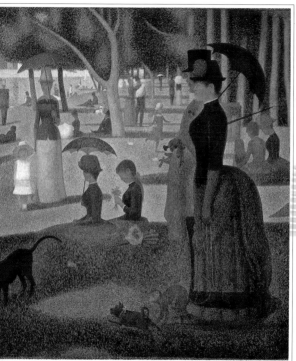

**The Seine at
Courbevoie**

Oil on canvas
1885 – 6
81.5 × 65 cm

The landscapes of Seurat's divisionist
maturity are perfectly controlled, if
somewhat soporific arrangements. This
one is enlivened only by the small dog
and, to a lesser extent, its mistress, a
refugee from *La Grande Jatte* who must
be beginning to suspect that she is only
wanted for her verticality.

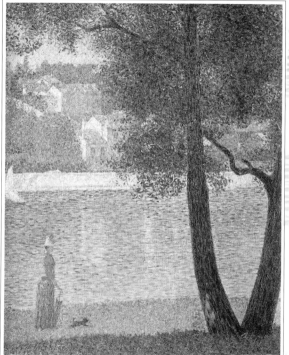

**The Beach at
Bas-Butin, Honfleur**

Oil on canvas
1886
66 × 82 cm

Seurat spent the summers of 1885 and
1886 at various locations along the
Normandy coastline, painting
seascapes and working out more fully
his theories of divisionism. He was to
continue dividing his time between
Paris and the Channel coast.

Seated Model, Profile
Study for
The Models

Oil on panel
1886 – 7
24 × 15 cm

For *The Models,* one of Seurat's largest
and most ambitious compositions,
the same model was posed in three
different attitudes in the artist's studio.
Numerous preparatory studies were
carried out in both charcoal and oils.

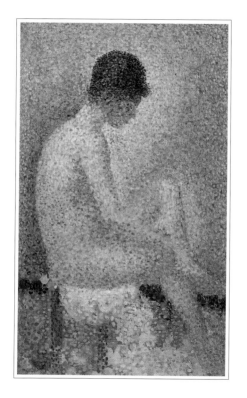

***Seated Model, Back
View***
Study for *The Models*

Oil on panel
1886 – 7
24.5 × 15.5 cm

The finished painting of *The Models*
is divided down the centre by a
standing figure, facing the viewer
impassively. This seated figure is on the
left, her top half silhouetted against the
canvas of *La Grande Jatte,* which
occupies almost half of the
background.

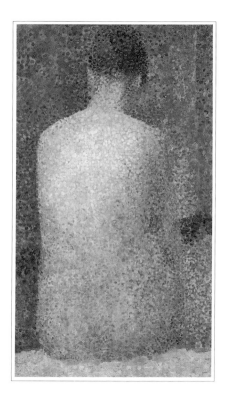

The Bridge at Courbevoie

Oil on canvas
1886 – 7
46 × 55 cm

The subordination of content to design makes this one of Seurat's more abstract landscapes. The familiar flat horizontals are joined by a series of precise verticals, including the perfunctory figures, thus dividing the central area into rectangular spaces.

Overleaf - In its subject – matter about as far removed from *The Bridge at Courbevoie* as it could be, *La Parade* nevertheless echoes the landscape's geometrical composition with remarkable fidelity, the larger figures, like its crooked tree, providing relief within the rigidly vertical pattern.

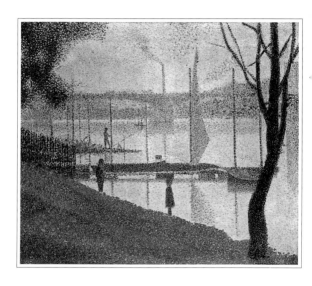

La Parade

Oil on canvas
1887 – 8
99.5 × 150 cm

**The Harbour
and Quays at
Port-en-Bessin**

Oil on canvas
1888
67 × 84.3 cm

The subjects of Seurat's later work
tended to be either figures in indoor
settings or landscapes more or less
devoid of people. This is a rare
example of an outdoor scene in which
the figures seem to exist in their own
right rather than as mere components
of the design.

The Eiffel Tower

Oil on wood
1889
24.2 × 15.2 cm

Nothing can have seemed more
modern in 1889 than Seurat's treatment
of the Eiffel Tower. There is no
pretence of rendering faithfully what
was before his eye, and the structure
itself was not yet even complete at the
time.

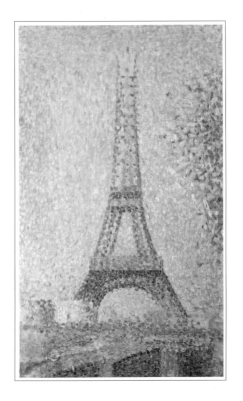

Study for
Le Chahut

Oil on panel
1889 – 90
21.5 × 16.5 cm

Although the cabaret *milieu* beloved of
Degas and Toulouse-Lautrec loses its
seediness and character when filtered
through Seurat's system, the study
succeeds brilliantly in design terms –
and the painting itself was to become
an icon for the Cubists.

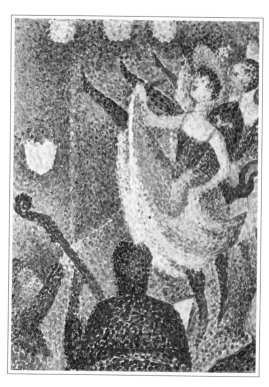

***Young Woman
Powdering Herself***

Oil on canvas
1889 – 90
95 × 79 cm

Seurat was only 31 when he died, but
his theories and example had already
had a major influence on others, and
later works such as this masterly,
admiring portrait of Madeleine
Knobloch, his common-law wife and
the mother of his son, demonstrate the
sheer distance he had travelled
artistically in his brief career.

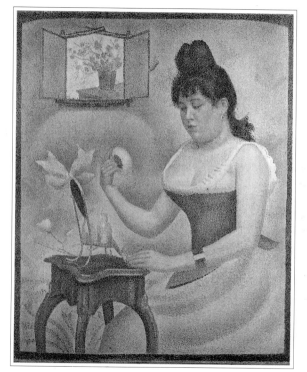

Cover:
Monet
Wild Poppies
Musée d'Orsay, Paris

Pissarro

p10 *Self Portrait* (detail)
Oil on canvas, 1903, 41 x 33 cm
Tate Gallery, London
p15 *The Entrance to the Village of Voisins*
Musée d'Orsay, Paris
p17 *The Road to Louveciennes*
Musée d'Orsay, Paris
p18-19 *Landscape, Pontoise*
Musée d'Orsay, Paris
p21 *The Little Bridge, Pontoise*
Stadtische Kunsthalle, Mannheim
p23 *Harvesting at Montfoucault*
Musée d'Orsay, Paris
p25 *Red Roofs, Corner of a Village, Winter*
Musée d'Orsay, Paris
p27 *Orchard with Flowering Fruit Trees,
Pontoise*
Musée d'Orsay, Paris

Manet

Degas

Monet

Rousseau

Seurat

p360 *Seurat* by Maximilien Luce supplied by
Bibliothèque National, Paris.